RUDOLF NUREYEV

Front cover:
 Rudolf Nureyev in *Le Corsaire pas de deux,* 1962
Inside front cover:
 With Margot Fonteyn during a break in rehearsal for *Pélléas et Mélisande,* 1969
Inside back cover:
 left to right: Laura Connor, Ann Jenner, David Wall, Rudolf Nureyev and Anthony Dowell in *Dances at a Gathering,* 1970
Back cover:
 As Armand in *Marguerite and Armand,* 1963

RUDOLF NUREYEV
AND THE ROYAL BALLET

EDITED BY CRISTINA FRANCHI

OBERON BOOKS
LONDON

First published in 2005 by the Royal Opera House
in association with Oberon Books Ltd
Oberon Books
521 Caledonian Road, London N7 9RH
Tel 020 7607 3637 Fax 020 7607 3629
oberon.books@btinternet.com
www.oberonbooks.com
Compilation copyright © Royal Opera House 2005
Text copyright © Royal Opera House 2005
Photographs © the copyright holders
The Royal Opera House and Cristina Franchi are hereby identified as
authors of this book in accordance with section 77 of the Copyright,
Designs and Patents Act 1988. The authors have asserted their moral
rights.

ISBN 1 84002 462 3

Cover and book design: Jeff Willis

Publication Assistant: Renata Bailey

Acknowledgements: Cristina Franchi would like to thank all the
photographers and copyright holders who have allowed us to share
their wonderful images. She would also like to thank Sir John Tooley,
Alex Kelly, Rudolf Nureyev Foundation, designers Jeff Willis and Sue
Perks, Dan Steward and Stephen Watson at Oberon, Georgina Matthews
at Team Photographic and at the Royal Opera House Monica Mason,
Jeanetta Laurence, Anne Bulford, Rebecca Erol, Francesca Franchi,
Renata Bailey and Samya Waked without whom this book would not
have been possible.

Printed and bound in Great Britain by Antony Rowe Ltd, Chippenham.

Photographic Credits

Catherine Ashmore 118
Joe Bangay 37, 48, 50 (above & below), 51 (above), 105
Judy Cameron 80, 81, 82
Anthony Crickmay, Theatre Museum, Victoria & Albert Museum
 13, 20, 24, 26, 27, 31, 41, 44, 53, 72, 75, 78, 79, 93, 96, 97,
 99, 101, 116, 117, 119, inside back cover
Alan Cuncliffe 45
David Daniel 114
Frederika Davis front cover, 6, 19, 33, 34, 39, 62, 64 (below), 68
 (above & below), 69, 70, 71, 74, 103, 121 (above)
Mike Davis 54
Zoë Dominic 15, 55, 59, 106
Fred Fehl 38
Felix Fonteyn 12, 14
Original photographs from the Margot Fonteyn Collection,
 Royal Opera House Archives 12, 14, 53, 54, 99, 121 (below)
C. Leiber/Paris Opéra 132
Y. Lessov 9 (below)
Nigel Luckhurst 111
Mira 49, 60
Original photographs from the Rudolf Nureyev Foundation
 8 (above & below), 9 (above & below), 11 (above)
Houston Rogers, Theatre Museum, Victoria & Albert Museum
 11 (below), 18, 28, 56, 112, 122 (above)
Roy Round 22, back cover
Geoffrey Sawyer 52
Leslie E. Spatt 17, 37, 46, 47, 51 (below), 61, 63, 87, 88, 89, 90,
 94, 95, 98, 100, 107, 115, 120
Donald Southern Collection, Royal Opera House Archives 7, 32, 35,
 36, 43, 64 (above), 65, 66, 67, 83, 85, 86, 102, 108, 110, 113,
 123 (above), 125 (above & below), 126 (both), 127, 128, 129
 (both), 130 (both)
Y. Umnov 10 (above)
Jennie Walton inside front cover, 16, 21, 29, 40, 57, 58, 76, 77, 84,
 91, 92, 104, 105, 109, 123 (below)
Rosemary Winckley 122 (below)
Tamara Zakrzhevskaya 9 (above)

Every effort has been made to trace the photographers of all pictures
reprinted in this book. Acknowledgement is made in all cases where
photographer and/or source is available.

CONTENTS

FOREWORD

1961 was an exceptionally important year for the Royal Opera House as two charismatic and dynamic performers arrived in its midst, one a musician and the other a dancer, both intent on a quest for perfection and both seized with a determination to succeed. The former was, of course, Sir Georg Solti, and the latter, Rudolf Nureyev, who had defected from the Kirov Ballet as it was leaving Paris for its London season in June. Nureyev himself arrived in London in November to dance in a Gala performance organised by Margot Fonteyn in aid of The Royal Academy of Dancing. This led to an immediate invitation from Ninette de Valois to join The Royal Ballet in the following February and shortly after this he was invited to become a Permanent Guest Artist.

De Valois, with her remarkable perception and vision, saw what a huge asset Nureyev would be to The Royal Ballet: 'We need a virtuoso *danseur noble*,' declared Dame Ninette, 'and here we have that rarity, one with taste.' She also saw Nureyev as a possible partner for Fonteyn and that was the beginning of one of the truly great ballet partnerships as they embarked on a series of memorable performances of *Giselle*.

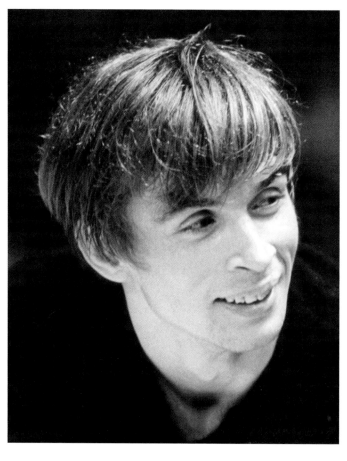

Even in those early days Nureyev was showing discontent with the generally accepted view of the role of the male dancer by making changes to productions to enhance the status of the *danseur noble* and to increase the dramatic impact of ballet on audiences. Those *Giselle* performances, for example, showed what effect changes he introduced could have, not only to the advantage of Albrecht but in the greater clarity in the unfolding of the ballet's story. For him the *danseur noble* was no cardboard figure, simply there to support the ballerina, but a living person capable of a wide range of emotions and expressing them through dance.

Nureyev, with his ready recall of many of the ballets which he had performed or seen at the Mariinsky Theatre, was keen to try his hand at their reproduction. For The Royal Ballet his first foray into the re-creation of the nineteenth century classical repertoire was *La Bayadère Act IV, The Kingdom of Shades*, and a huge success it was. His coaching of the dancers was a revelation. He would encourage the taking of risks and the attempting of what was often regarded as impossible. That word was not in his vocabulary, nor would he permit it in others. He would encourage, cajole, shout and behave outrageously in his

Rudolf Nureyev during a rehearsal for *La Sylphide*, 1963

demands, but often his saving grace was his obvious delight in others' achievements as well as his own. His other re-creations for The Royal Ballet were *The Nutcracker* and *Raymonda Act III.* He had previously mounted the full-length *Raymonda* on The Royal Ballet Touring Company in Spoleto.

Nureyev was not content just with mounting productions of earlier ballets, he was driven by his boundless energy to create new works. These never quite enjoyed the success of the reproduced works and rarely survived long in any company's repertoire. For The Royal Ballet he created *The Tempest*; works for other companies included *Manfred* and *Washington Square*, and all deserved a better fate.

Nureyev had been a late starter, a fact which undoubtedly influenced his work ethic and caused him to leave nothing to chance, never to let up and constantly to push himself harder and harder. That he achieved entry to the Vaganova School in St Petersburg at all was something of a miracle, and it was his good fortune that the great teacher Alexander Pushkin spotted talent in this then uncouth youth. All of this was the product of his persistence and utter determination to dance, an obsession which had dominated his life from a young age. He struggled, in abject poverty, to attend ballet class in Ufa, in the face of hostility from a father who could not come to terms with the idea of his son being a dancer. Rudolf simply had to dance. He saw himself on this earth for this purpose and could never imagine a life where dance did not prevail. This was his life and the stage his home.

His demand for performances was insatiable and The Royal Ballet was later to find it increasingly difficult to satisfy him and at the same time give others the opportunities they badly needed. Other companies and other audiences were to benefit from his colossal appetite for performance and Paris enjoyed an astonishing era of ballet when he became Director of the Paris Opéra Ballet in 1983.

This beautifully illustrated book concentrates on his time with The Royal Ballet, with some photographs of pre-defection days in Russia. It is a splendid pictorial tribute to one of the greatest performing artists of the last century who changed the face of ballet and attitudes towards it as a serious art form.

John Tooley
Chairman, Rudolf Nureyev Foundation

John Tooley was Assistant to David Webster, General Administrator at the Royal Opera House, when Nureyev came to Covent Garden in 1962, becoming General Director in 1970, a post he held until 1988.

left to right: John Tooley, General Director of the Royal Opera House, HRH The Princess Margaret, Sulamith Messerer and Rudolf Nureyev after the Gala Night of Ballet in celebration of Dame Ninette de Valois' 90th Birthday, 6 June 1988

EARLY LIFE, KIROV BALLET, DEFECTION

Rudolf Nureyev was born on a train travelling through Eastern Siberia on 17 March 1938, an event which with hindsight appears a portent of what his life would become. His father Hamet worked as a political officer in the Red Army and had been posted to Vladivostock. His mother Farida was travelling to rejoin Hamet, accompanied by Nureyev's three sisters Rosa, aged eight, Lilya, aged seven and Razida, aged three. The family was Moslem Tartar from peasant stock and Hamet's Fasliyev relatives traced their lineage back to Genghis Khan and the Mongol armies who conquered Russia in the thirteenth century. Nureyev was always proud of his Tartar roots, describing how, 'Tartar blood runs faster somehow, is always ready to boil. (Tartars are) a curious mix of tenderness and brutality – a blend which rarely exists in the Russian…quick to catch fire, quick to get into a fight, unassuming, yet at the same time passionate and sometimes as cunning as a fox. The Tartar is a pretty complex animal and that's what I am.'

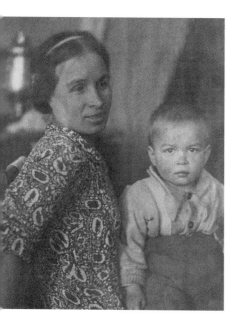

When Nureyev was 17 months old, Hamet was transferred to Moscow and life improved briefly for the family. In 1941, Hamet was posted to the Western Front and he was not to see his family again until 1946. During the early war years the family lived in abject poverty at Chelyabinsk before settling near relatives in Ufa. Nureyev referred to this time as the 'potato years' as that is what the family subsisted on and his memories of that time were 'icy and dark and above all hungry'.

Farida was to say many years later that, 'My Rudik was the best dancer in the kindergarten.' The young Nureyev loved music, dance and singing. He adored the folk dancing he had been introduced to in kindergarten and was soon invited to join the children's ensemble which gave local concerts. On New Year's Eve 1945, Farida with only one ticket somehow managed to smuggle all four children into a performance of the Ufa Ballet! The seven-year-old Nureyev saw his first ballet and from that moment on he knew he had to be a ballet dancer. His father, who returned home when Nureyev was eight, did not approve and would beat him if he found out Nureyev had been to a dance class. Nureyev managed to have his first ballet lessons aged ten with Anna Udeltsova, a former ballerina from Leningrad who had been exiled to Ufa. Udeltsova

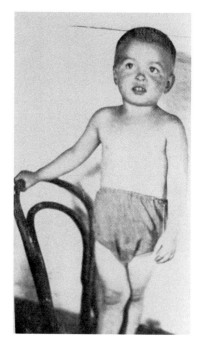

fuelled his ambition to go and study at the Vaganova Choreographic Institute in Leningrad. Through classes with Elena Voitovich, he gained access to the studio of the Ufa Ballet Company and in 1953 he was taken on as a stage extra by the Company, using this as an opportunity to take their classes whenever he could.

left: The young Nureyev with his mother Farida
right: Nureyev as a toddler

Nureyev auditioned before Vera Costravitskaya at the Vaganova Choreographic Institute in Leningrad on 25 August 1955. He was already 17 and in ballet terms had had very little formal training. Costravitskaya's ability to spot talent was legendary and her verdict on Nureyev was unequivocal: 'Young man, you'll either become a brilliant dancer – or a total failure… Most likely you'll be a total failure!' Nureyev knew she meant he had the ability but that he would have to work exceptionally hard to avoid failure. He seized his chance and threw himself into the life of the school, working at an incredible rate. It was his great fortune to be given Alexander Pushkin as his teacher. Not only an inspirational teacher, perhaps the only teacher capable of nurturing the rebellious young Nureyev, he also became a friend and surrogate parent. Life in Cold War Russia was hedged by rules but Nureyev refused to be constrained by these just as he refused to join the Communist party at a time when all dancers were expected to be party members. The quest for knowledge about dance, music, art was his driving force. He attended dance and theatre performances whenever he could and sought out visiting dancers and companies. These things were forbidden but his talent was such that somehow he managed to get away with it.

Nureyev gave sensational performances during 1958, his graduate year, and became the first dancer since Vaslav Nijinsky to be invited to join the Kirov Ballet Company as a soloist rather than as a member of the *corps de ballet*. If that were not extraordinary enough, for his first performances he was asked to partner one of the leading ballerinas Natalia Dudinskaya.

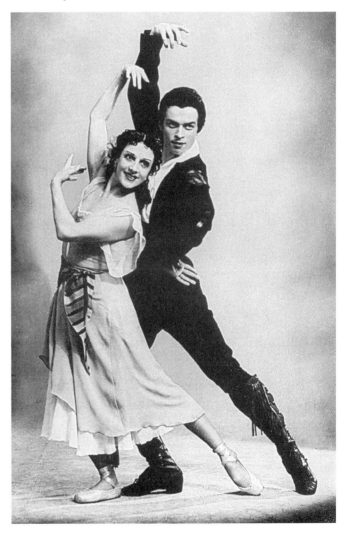

left: Nureyev with his teacher Alexander Pushkin, near the Mariinsky Theatre in 1959
right: With Natalia Dudinskaya in *Laurentia,* 1958

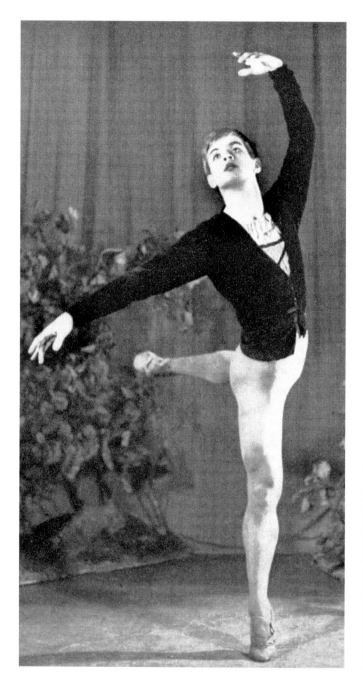

Nureyev quickly became a favourite with audiences and by the time the Kirov Ballet came to tour Europe in 1961, Nureyev was an established star. His dancing at the Palais Garnier, home of the Paris Opéra, caused a sensation. Offstage, Nureyev evaded his KGB escorts and explored Paris, went to the theatre, made new friends and stayed out late. This behaviour made him a security risk as far as the Russians were concerned. The Company was at Orly airport about to go on to the London part of the tour when Nureyev was told he had been recalled to Moscow supposedly to dance at the Kremlin. He knew what that meant and so it was that on 16 June 1961, he defected to the West, causing a media sensation. This media interest never really abated and over the next 30 years Nureyev was not only to clock up a record number of performances around the world with a staggering number of companies but he was also to become the most photographed dancer of all time.

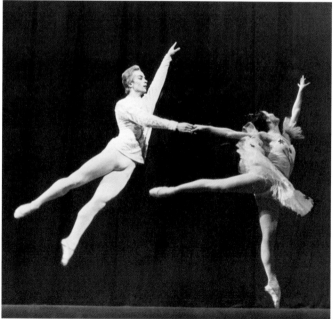

left: The commemorative souvenir programme, prepared for the visit of the Kirov ballet to London in 1961, shows Nureyev as Albrecht in *Giselle* and describes him as 'one of the most exciting dancers to emerge in the last decade and also one of the youngest to dance the role of Albrecht'
right: With Alla Sizova in *The Nutcracker,* 1959

Nureyev's first performance in London was at a Gala matinée on 2 November 1961 in aid of the Royal Academy of Dancing, organised by their president Margot Fonteyn. Nureyev danced *Poème tragique,* a solo he had asked Frederick Ashton to create for him. Watching his curtain call, Ninette de Valois knew she had to ask him to dance with The Royal Ballet.

Nureyev's first appearance with the Company was as Albrecht with Margot Fonteyn as Giselle in a performance of *Giselle* on 21 February 1962. This was to be the beginning of Nureyev's long association with The Royal Ballet. He had an immediate impact on the career of Fonteyn, who had been on the point of retiring, and a huge influence on the emerging generation of young dancers. Anthony Dowell later compared his arrival to that of 'a meteor' and said, 'Rudolf was the stuff that dreams and legends are made of. He changed the destinies of all male dancers to come.' Monica Mason described him as someone 'who gave one hundred per cent and demanded the same of his partner; a real inspiration'. Nureyev appeared regularly with

The Royal Ballet as a Guest Artist during the 1960s and 1970s, toured America with the Company as well as touring extensively with Sadler's Wells Royal Ballet. He returned for occasional performances during the 1980s and his last appearance on stage at the Royal Opera House was in 1990.

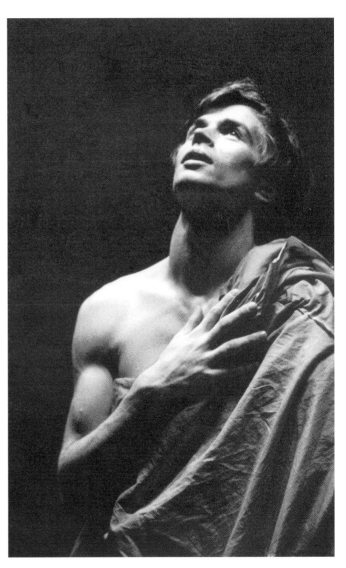

left: With Frederick Ashton during rehearsals for *Poème tragique,* 1961
right: Poème tragique, 1961

THE ROMANTIC REPERTOIRE: *GISELLE* AND *LES SYLPHIDES*

Rudolf Nureyev was invited to dance with The Royal Ballet in 1962, appearing as Albrecht with Margot Fonteyn as Giselle in a performance of *Giselle* on 21 February 1962. This was to be the beginning of Nureyev's long association with The Royal Ballet as dancer, producer and choreographer and also the beginning of one of ballet's legendary partnerships. Frederick Ashton, watching the

rehearsals of *Giselle* commented with a wry prescience that, 'It could be that the appearance of Margot Fonteyn and Rudolf Nureyev in *Giselle* will cause as big a stir as the performances of Pavlova and Nijinsky in the same ballet.' Nureyev had first danced Albrecht with the Kirov ballet in 1959. *Giselle* had always been seen as a ballerina's ballet but Nureyev's interpretation of Albrecht brought the male

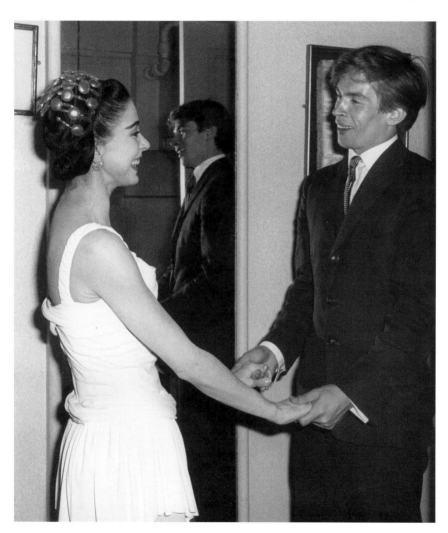

dancer into focus. His Albrecht was a recognisable character. A privileged young man, by turns charming, arrogant and thoughtless, dodging his responsibilities and having a bit of fun, who discovers he really does love the simple peasant girl Giselle and is devastated by the tragedy he has so thoughtlessly wrought. Nureyev also added to the choreography, most notably the *entrechats six* in the second act, something considered little short of sacrilege at the time. Fonteyn had been dancing *Giselle* since 1937 but stimulated by Nureyev's dramatic interpretation, she found new depth of feeling and purity in the role of Giselle. De Valois described them as 'the ideal partnership' and commented that, 'One couldn't believe they had not sprung from the same school.'

Nureyev's other partners in that first season were fellow guest artists Yvette Chauviré and Sonia Arova. He appeared with Yvette Chauviré, who was noted for her interpretation of the romantic repertory, in both *Giselle* and *Les Sylphides,* as well as partnering her in *The Sleeping Beauty*.

With Margot Fonteyn in her dressing room at the Royal Opera House, Autumn 1961. Fonteyn is in costume for *Symphonic Variations*.

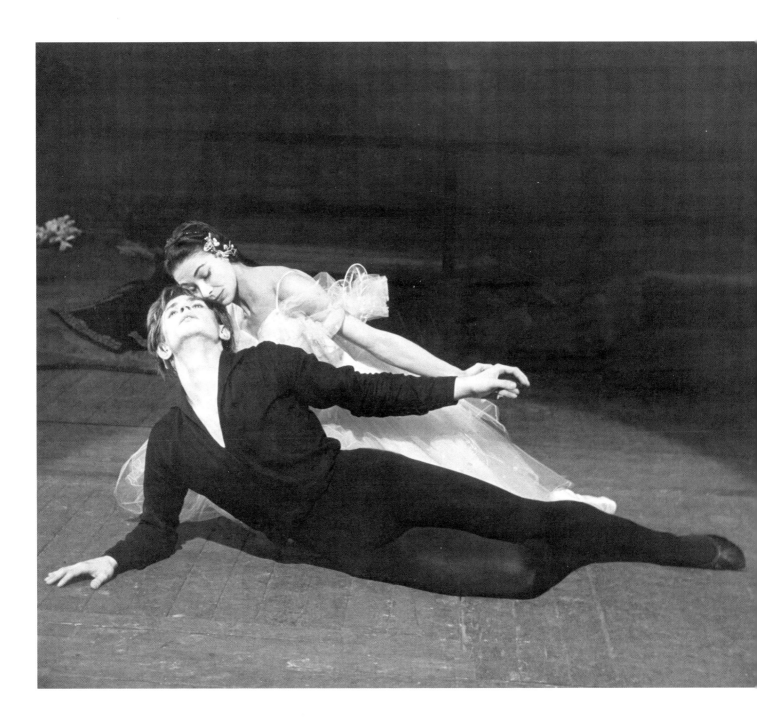

Rudolf Nureyev as Albrecht with Margot Fonteyn as Giselle in rehearsal for Act II of *Giselle*, 1962

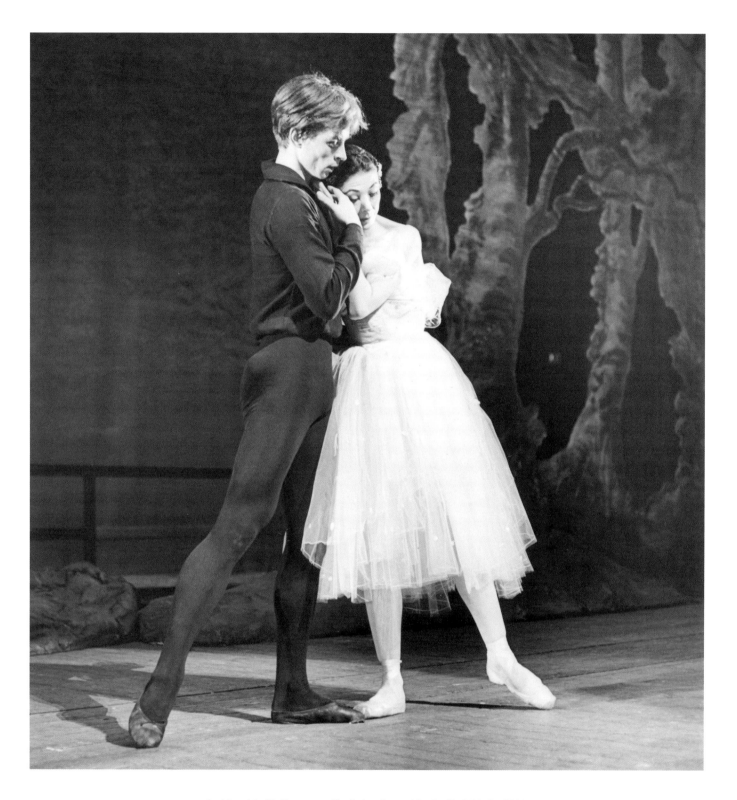

As Albrecht with Fonteyn as Giselle in rehearsal for Act II of *Giselle,* 1962

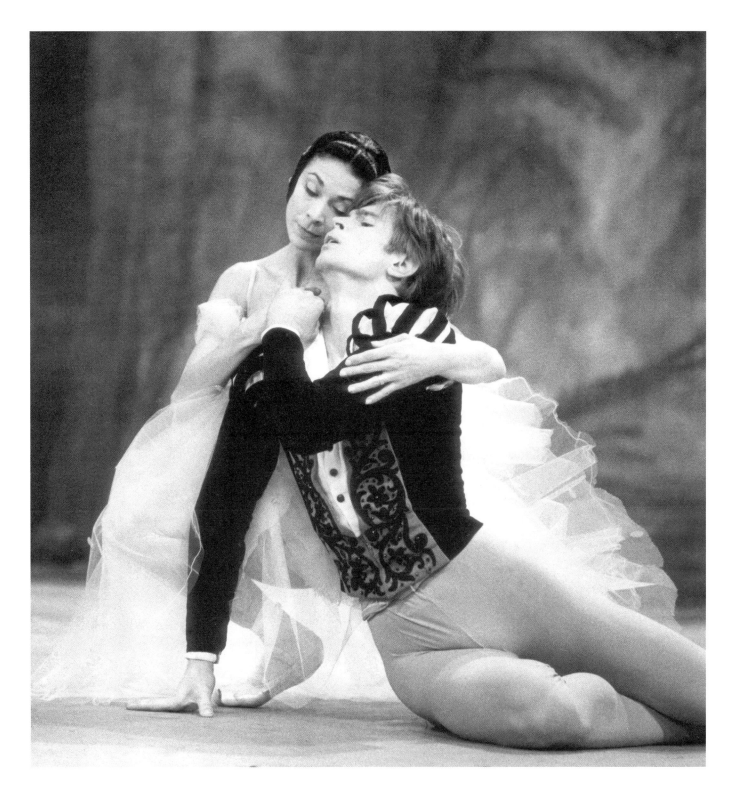

As Albrecht with Fonteyn as Giselle in Act II of *Giselle*, 1962

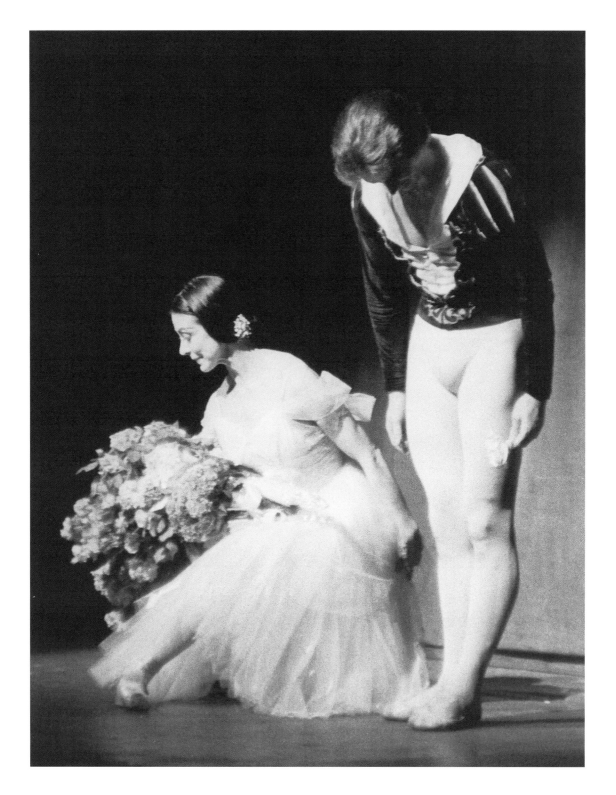

Fonteyn and Nureyev taking a curtain call after *Giselle,* 1970

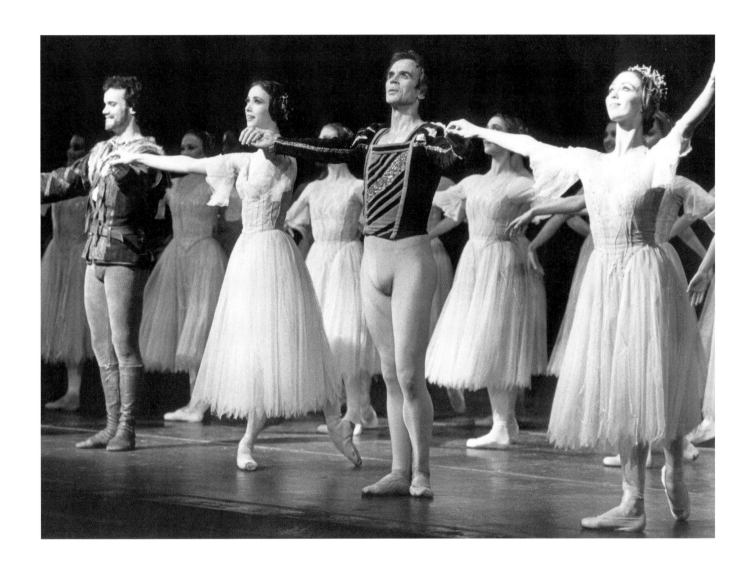

Nureyev became Artistic Director of the Paris Opéra Ballet in 1983.
In 1988, he brought his protégée Sylvie Guillem to make her debut at the Royal Opera House as Giselle.
Nureyev danced Albrecht, with Stephen Jefferies *(left)* as Hilarion and Fiona Chadwick *(right)* as Myrthe.

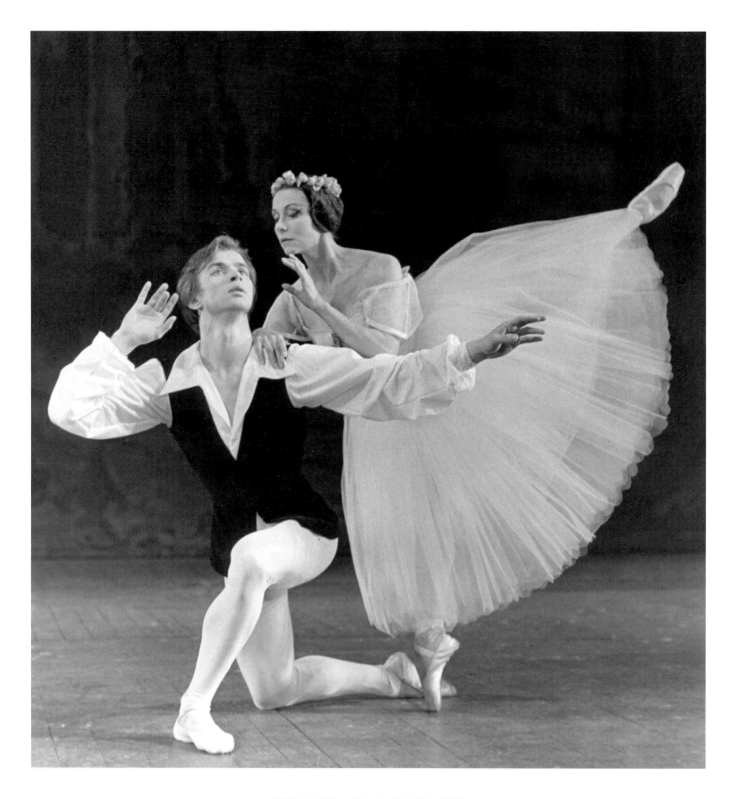

With Yvette Chauviré in *Les Sylphides,* 1962

THE PETIPA INHERITANCE:
LE LAC DES CYGNES, THE SLEEPING BEAUTY, LE CORSAIRE PAS DE DEUX, DON QUIXOTE PAS DE DEUX

Nureyev was steeped in the great classical ballets of Marius Petipa from his days with the Kirov Ballet and at the Vaganova School in St Petersburg. During his first season with The Royal Ballet in 1962 he appeared with fellow guest artist Sonia Arova in *Le Lac des cygnes* and in the bravura *Don Quixote pas de deux*. The wider British public had an opportunity to see his dancing when he appeared with The Royal Ballet ballerina Nadia Nerina, in the Black Swan *pas de deux* from *Le Lac des cygnes,* on the hugely popular live television programme *Sunday Night at the London Palladium.* He first danced The Royal Ballet's production of *The Sleeping Beauty* with Yvette Chauviré. Over the next twenty years, he was to dance these ballets with many ballerinas of The Royal Ballet, including Margot Fonteyn, Nadia Nerina, Antoinette Sibley, Merle Park, Lynn Seymour, Lesley Collier and guest artist Natalia Makarova, who had also been a member of the Kirov Ballet.

Nureyev brought his own noble style to the classical roles. As de Valois said, 'He lifted us into another dimension in the presentation and execution of the great Russian classics.' Nureyev also introduced an elegiac melancholic solo for Prince Siegfried in Act I of *Le Lac des cygnes* in 1962. When Robert Helpmann restaged *Swan Lake* in 1963, much of the additional choreography was by Ashton but he retained Nureyev's Act I variation as well as asking him to contribute a *Polonaise* in Act I and a *Mazurka* in Act II. The Act I Prince's variation was to be retained in further productions of *Swan Lake.*

Le Corsaire pas de deux, 1962

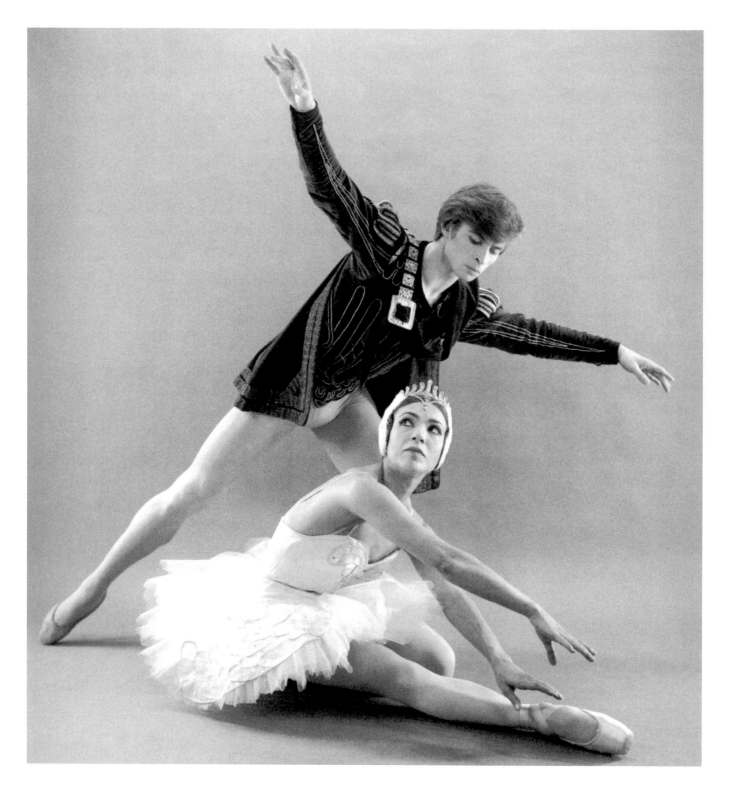

As Prince Siegfried with Sonia Arova as Odette in *Le Lac des cygnes,* 1962

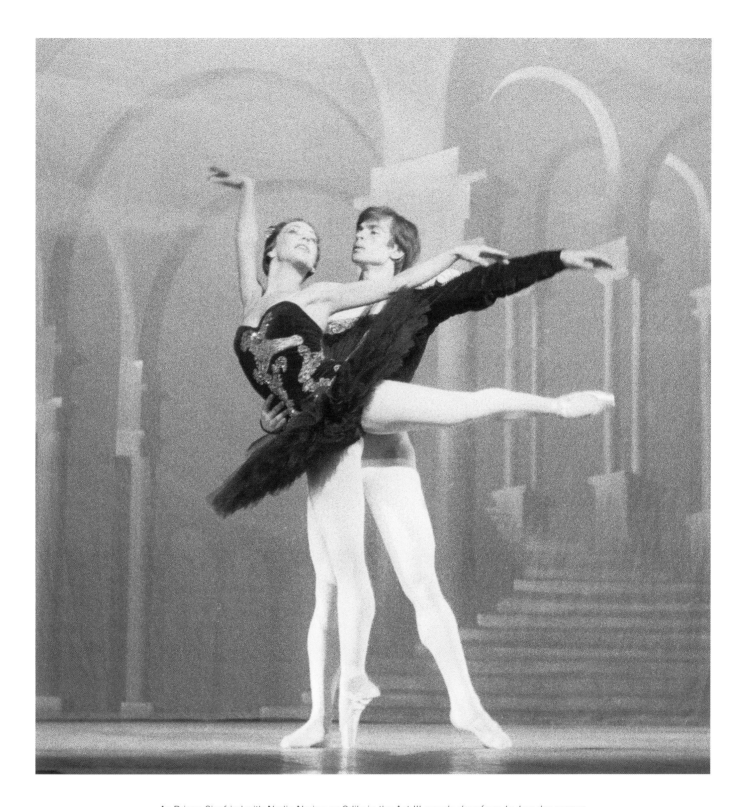

As Prince Siegfried with Nadia Nerina as Odile in the Act III *pas de deux* from *Le Lac des cygnes*,
dancing live on the highly popular television programme *Sunday Night at the London Palladium*, 1962

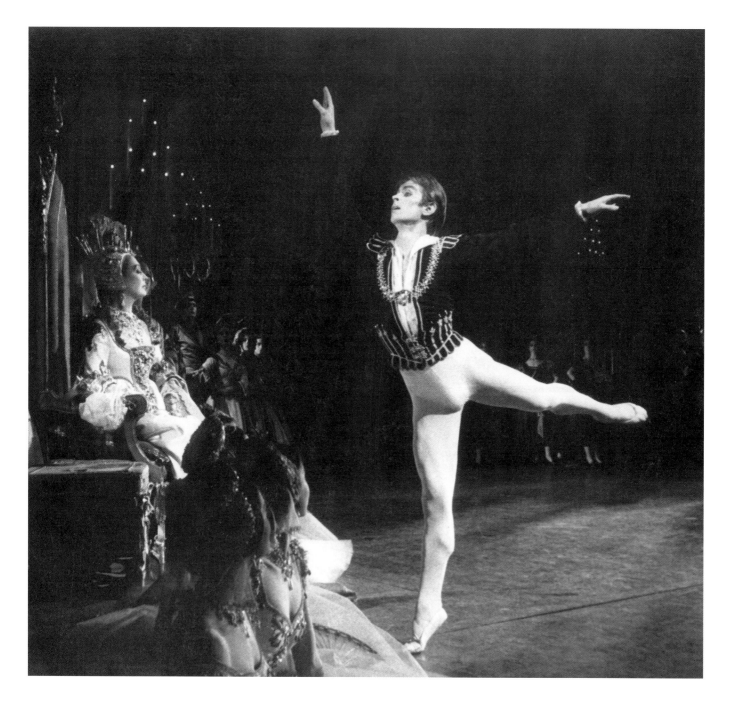

As Prince Siegfried in Act III of *Le Lac des cygnes,* 1963

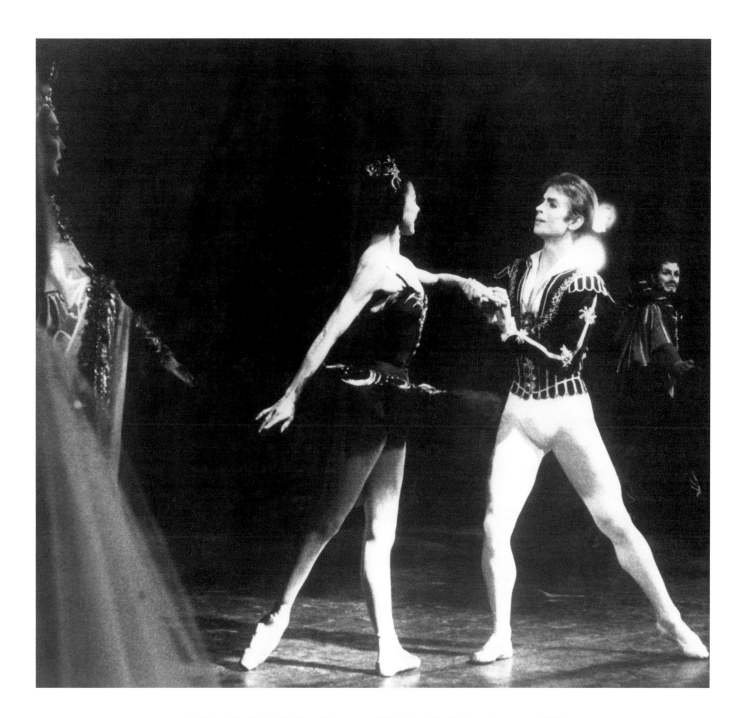

As Prince Siegfried with Margot Fonteyn as Odile in Act III of *Le Lac des cygnes,* 1963

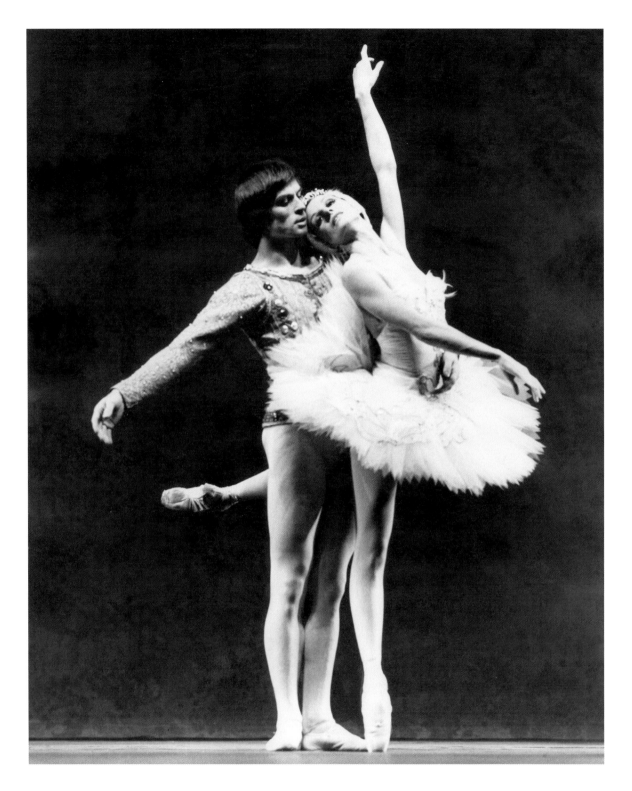

As Prince Siegfried with Merle Park as Odette in *Swan Lake*, 1974

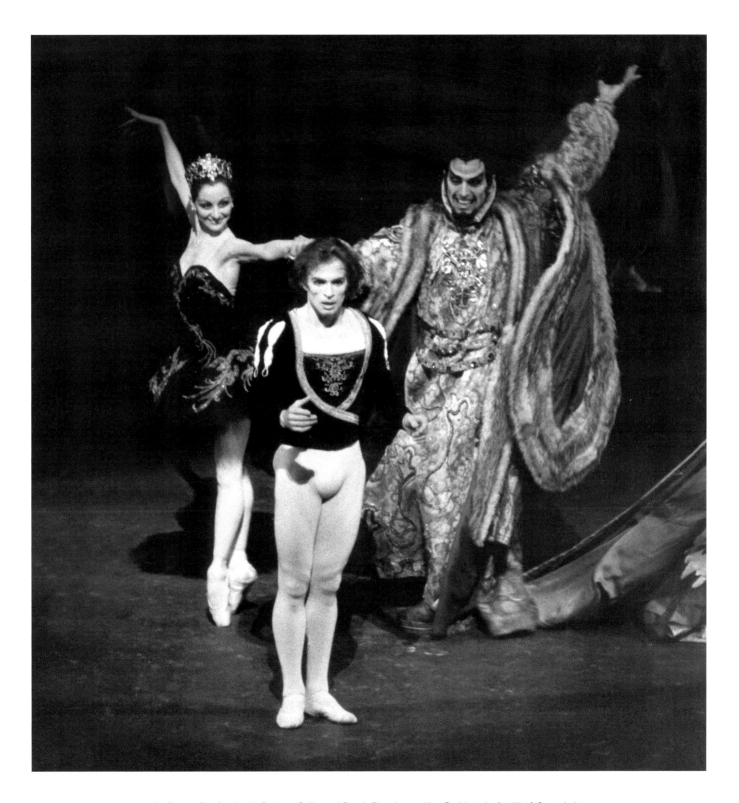

As Prince Siegfried with Park as Odile and Derek Rencher as Von Rothbart in Act III of *Swan Lake,*
Metropolitan Opera House New York, The Royal Ballet American tour, 1974

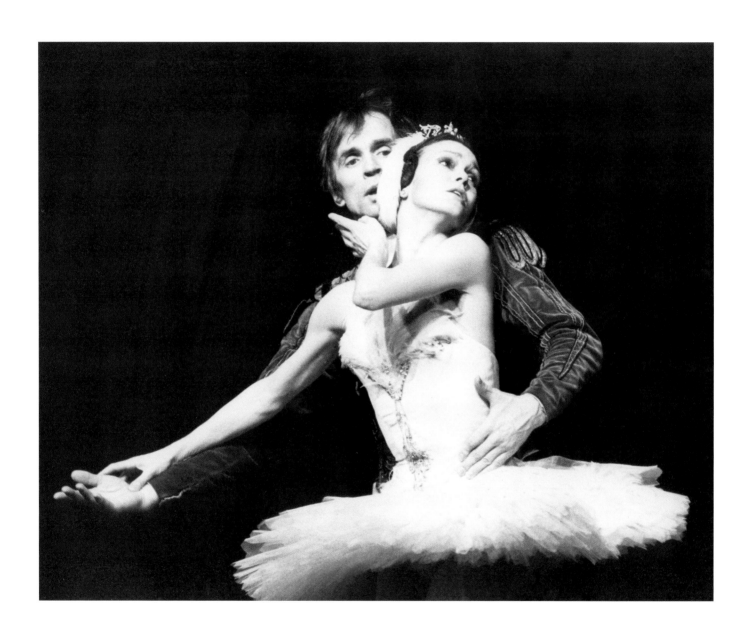

As Prince Siegfried with Lesley Collier as Odette in *Swan Lake,* 1982

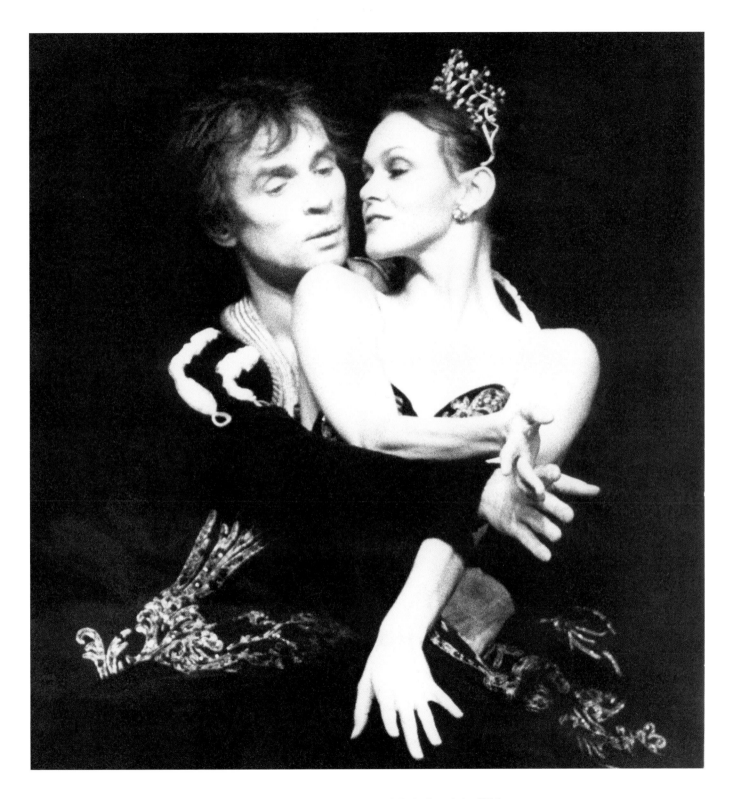

As Prince Siegfried with Collier as Odile in *Swan Lake,* 1982

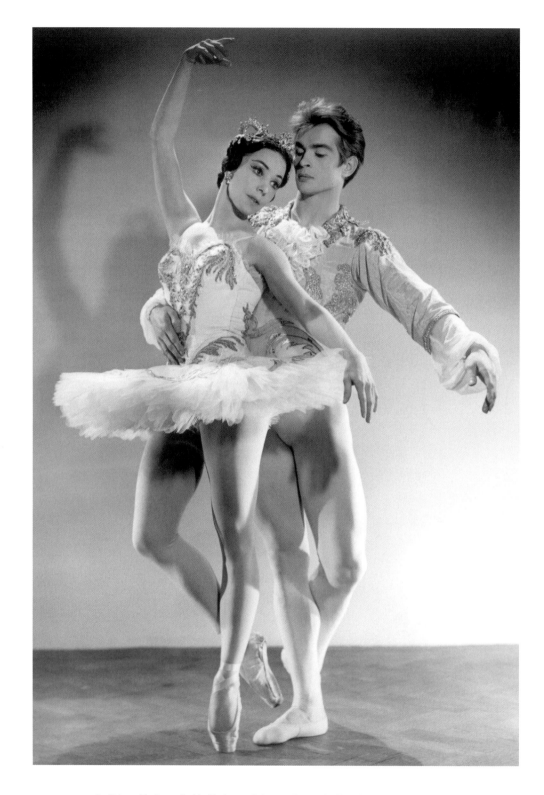

As Prince Florimund with Nerina as Princess Aurora in *The Sleeping Beauty*, 1962

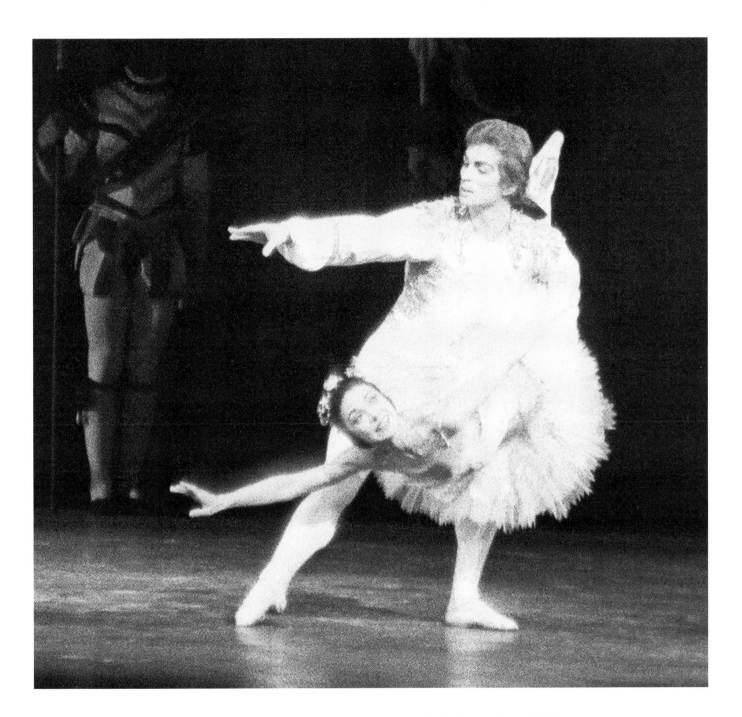

As Prince Florimund with Fonteyn as Princess Aurora in *The Sleeping Beauty,* 1966

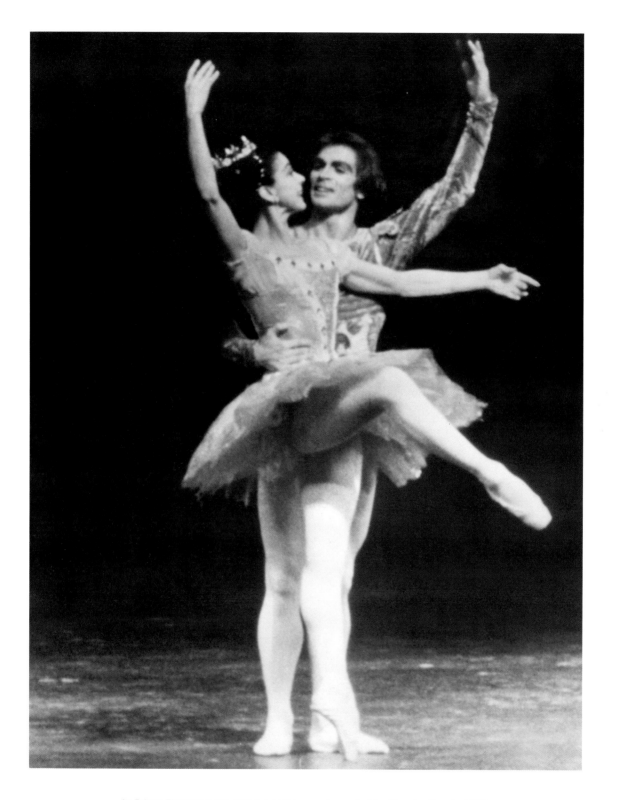

As Prince Florimund with Fonteyn as Princess Aurora in *The Sleeping Beauty*, 1970

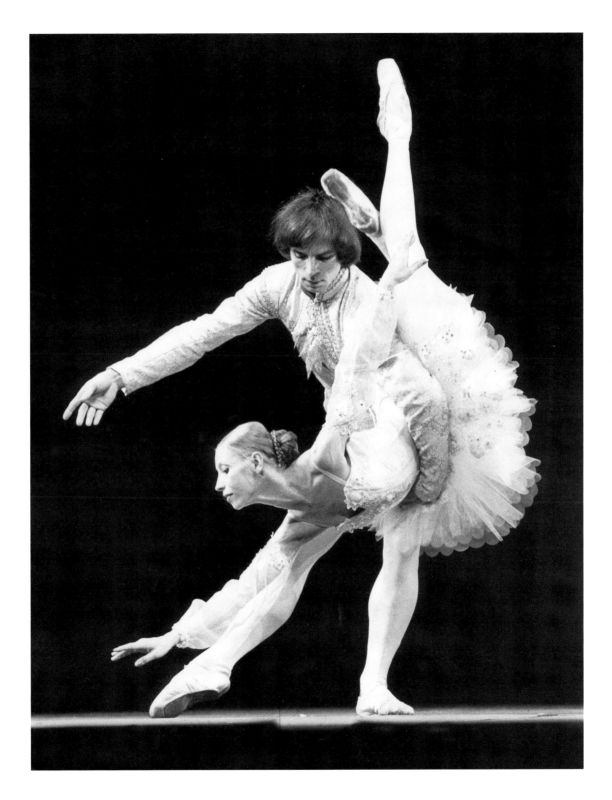

As Prince Florimund with Natalia Makarova as Princess Aurora in *The Sleeping Beauty,* 1973

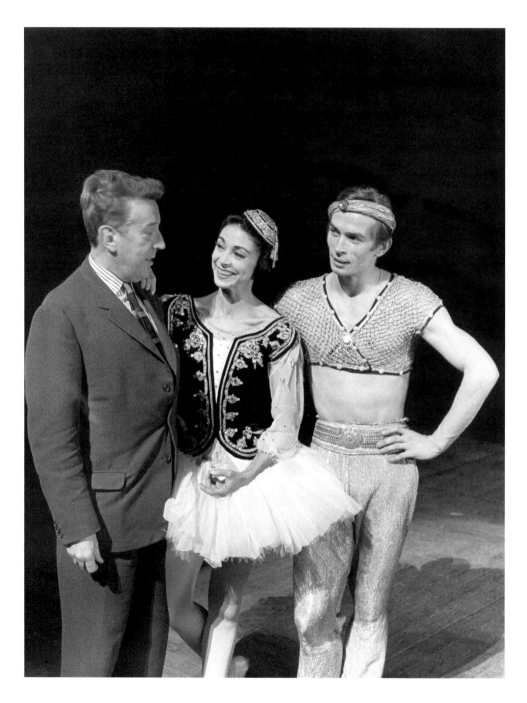

Nureyev had danced a solo from *Le Corsaire* at his graduation and at a student competition in Russia in 1958. The solo had caused such a sensation that he was compelled to dance it again. The effect was equally electric at Covent Garden in November 1962 when he staged the *pas de deux* for himself and Fonteyn. Their performance was immortalized in the 1963 film *An Evening with The Royal Ballet*, directed by Paul Czinner. They were often to dance it together over the next ten years.

left to right: Frederick Ashton with Margot Fonteyn and Rudolf Nureyev in costume for *Le Corsaire pas de deux*, 1962

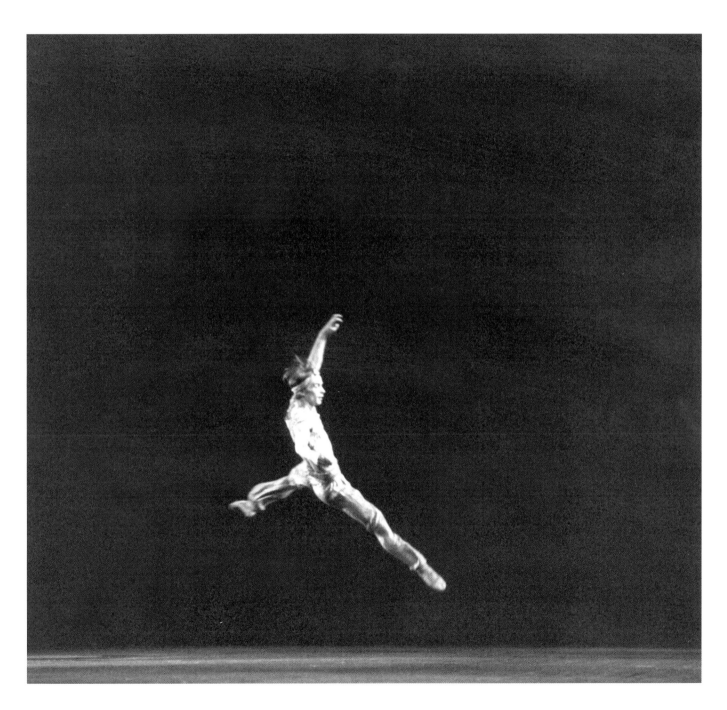

In flight *Le Corsaire pas de deux*, 1962

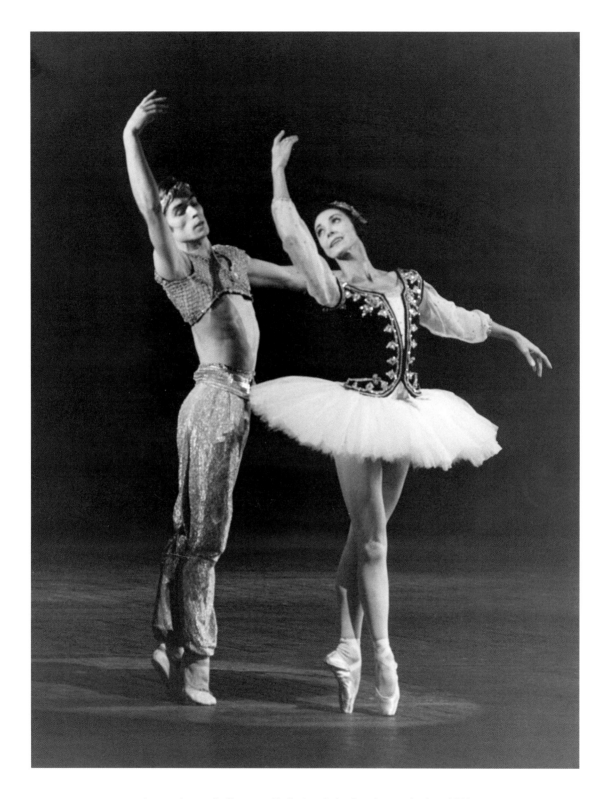

above and opposite: Nureyev with Fonteyn in *Le Corsaire pas de deux,* 1962

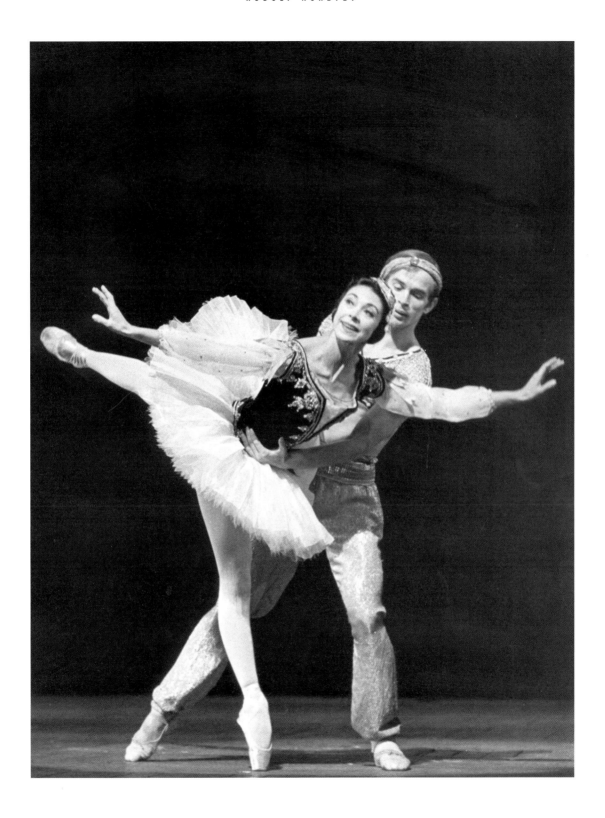

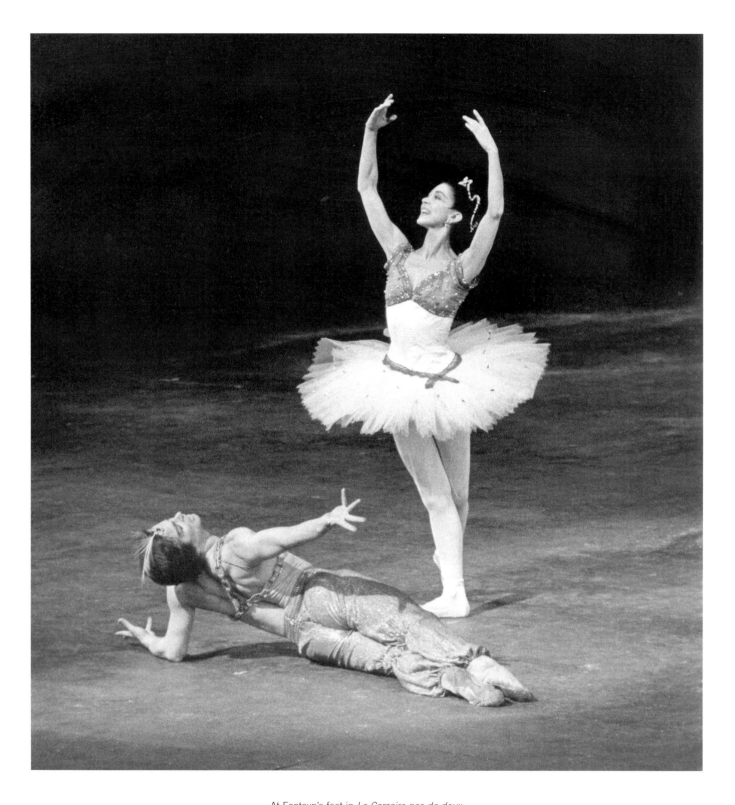

At Fonteyn's feet in *Le Corsaire pas de deux,*
Metropolitan Opera House New York, The Royal Ballet American tour, 1968

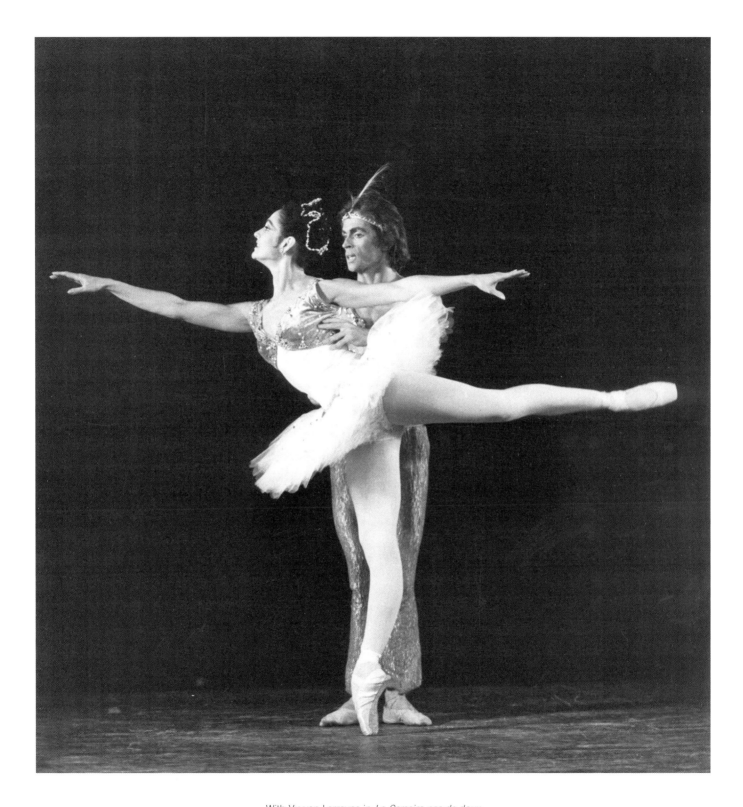

With Vyvyan Lorrayne in *Le Corsaire pas de deux,*
Sadler's Wells Royal Ballet tour to Israel, 1974

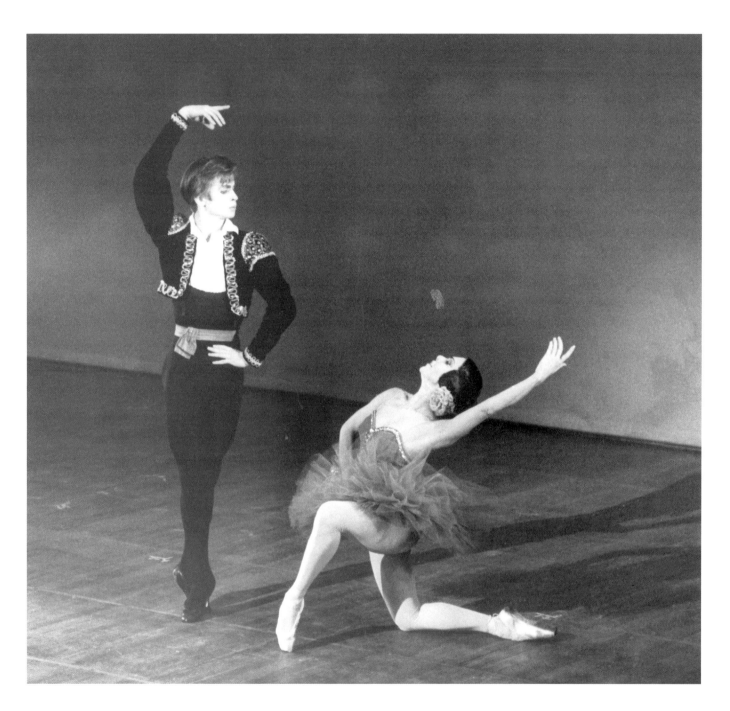

With Sonia Arova in the *Don Quixote pas de deux*, 1962

THE DIAGHILEV BALLETS OF FOKINE AND BALANCHINE

The Diaghilev ballets were not performed in the Russia Nureyev knew although the dancers were of course aware of them. Nureyev was keen to explore as much of this repertory as possible, especially the works associated with the legendary Vaslav Nijinsky and the early works of George Balanchine, who was one of his heroes.

Nureyev was familiar with Mikhail Fokine's choreography for *Les Sylphides* but his first opportunity to tackle the role of

Petrushka, the wretched puppet originally created by Fokine for Nijinsky, was with The Royal Ballet in 1963. The role of the tragic outsider set in Alexandre Benois' painterly evocation of St Petersburg took on a unique resonance when danced by the young defector. It was a role to which he returned and his later interpretations sought to convey that the puppet was aware of but not cowed by the inevitability of his destruction.

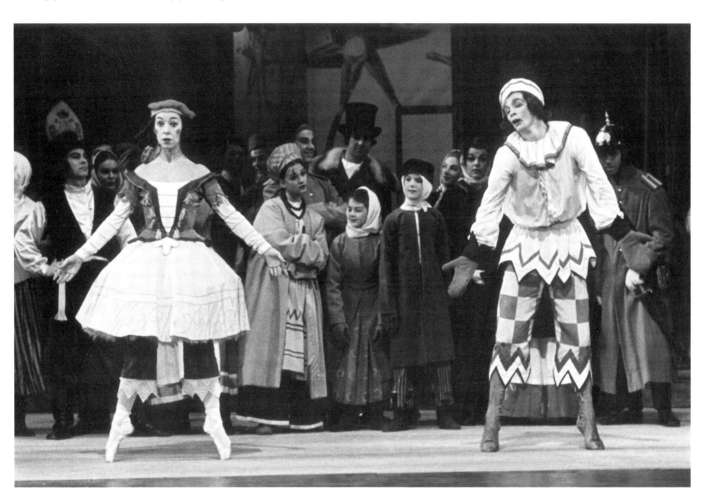

As Petrushka with Nadia Nerina as The Ballerina in *Petrushka,* 1963, choreography by Mikhail Fokine

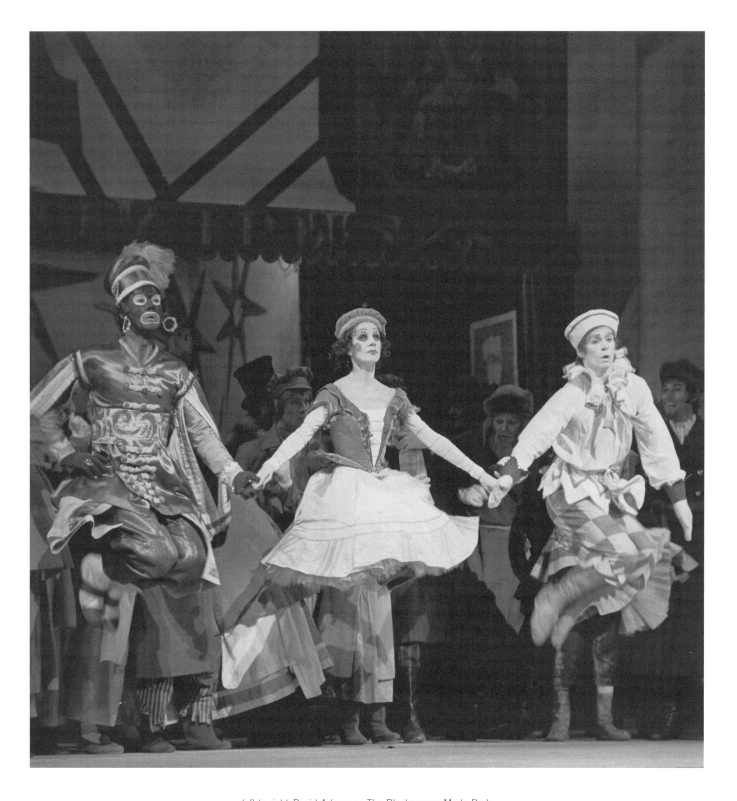

left to right: David Adams as The Blackamoor, Merle Park
as The Ballerina and Nureyev as Petrushka in *Petrushka,* 1975

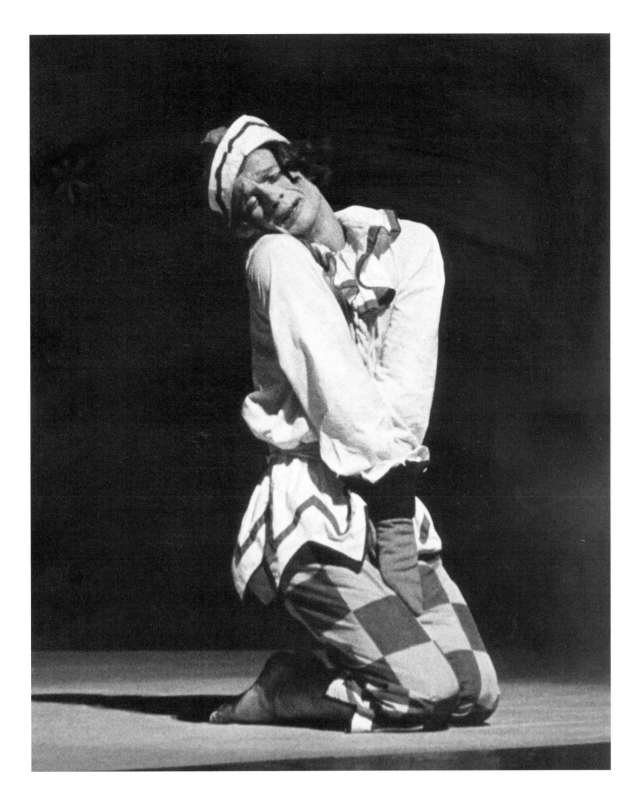

Petrushka, 1975

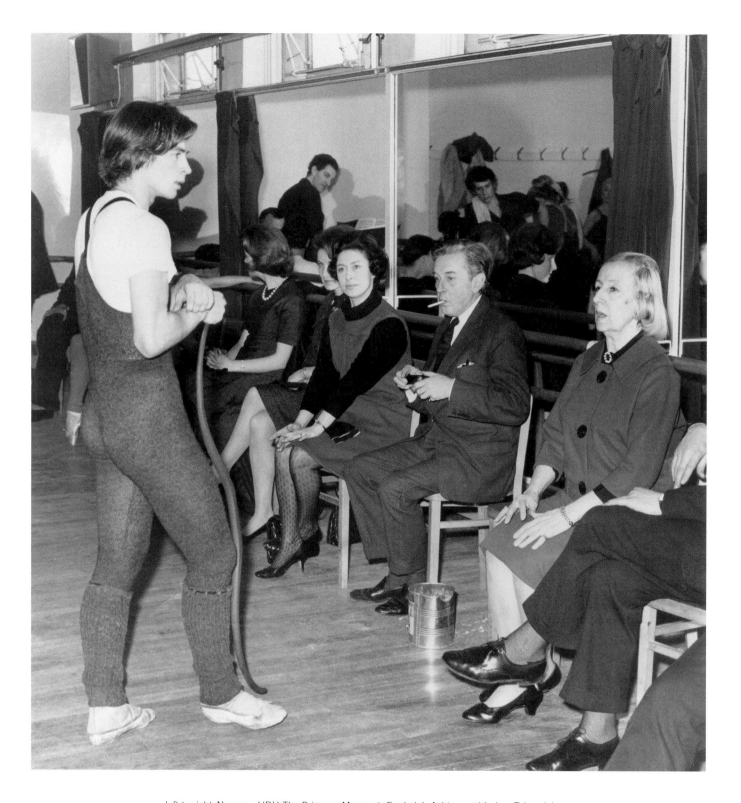

left to right: Nureyev, HRH The Princess Margaret, Frederick Ashton and Lubov Tchernicheva
during rehearsal for *Polovtsian Dances* from *Prince Igor* at The Royal Ballet School, 1965

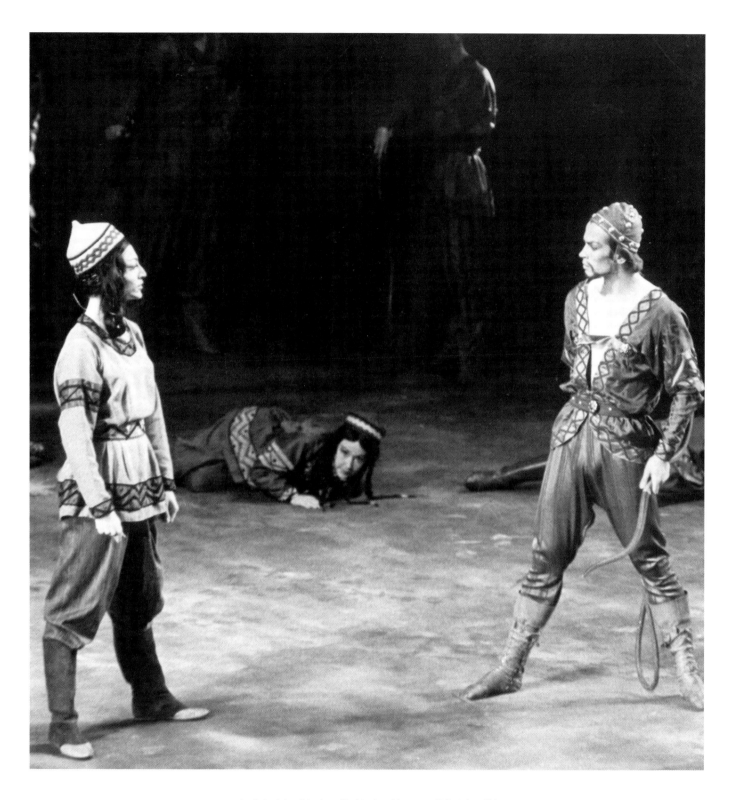

As Polovtsian Warrior with Monica Mason as Polovtsian Girl
in *Polovtsian Dances* from *Prince Igor,* 1965, choreography by Mikhail Fokine

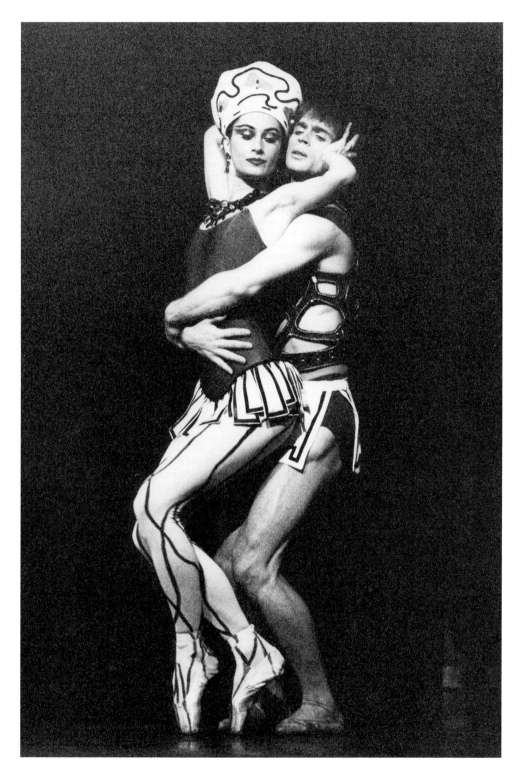

Nureyev gave a dazzling interpretation of the rebellious Prodigal in Balanchine's dance drama *The Prodigal Son,* when he appeared in the first performance of the work by The Royal Ballet in 1973. Deanne Bergsma was his stunning and sultry Siren.

Nureyev had first danced Balanchine's *Apollo* in 1967 and in 1971 he gave his first performances of the role with The Royal Ballet. The role of the god Apollo, with its mixture of classicism and modernity, could have been made for him. Apollo's progress from his fumbling birth until the final ascent into Olympus seemed like art imitating life, mirroring Nureyev's own personal and artistic journey.

He danced both roles at Covent Garden as well as on tour with The Royal Ballet in America and with Sadler's Wells Royal Ballet in Israel.

As The Prodigal Son with Deanne Bergsma as The Siren
in *The Prodigal Son,* 1973, choreography by George Balanchine

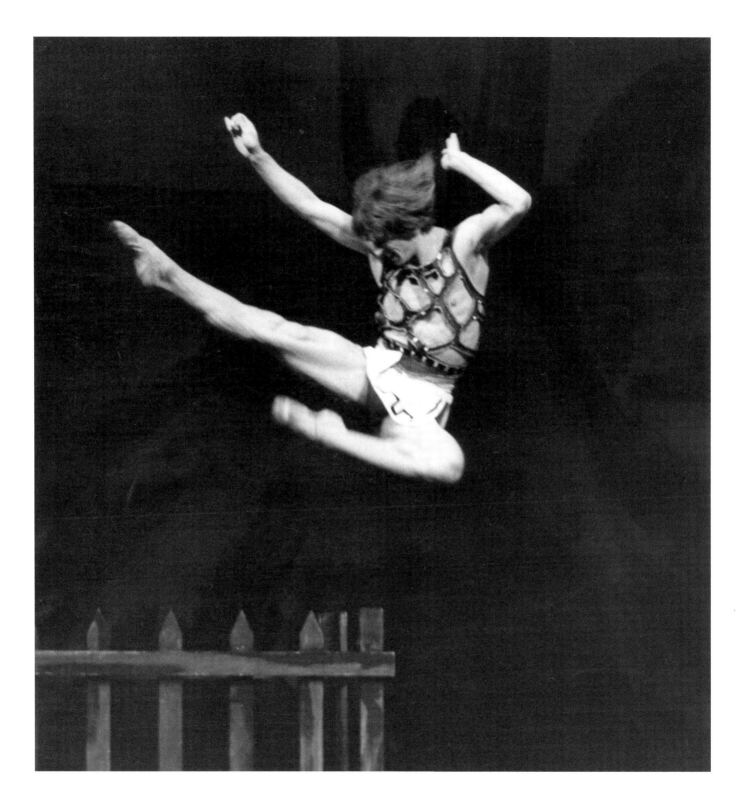

The Prodigal Son, 1973

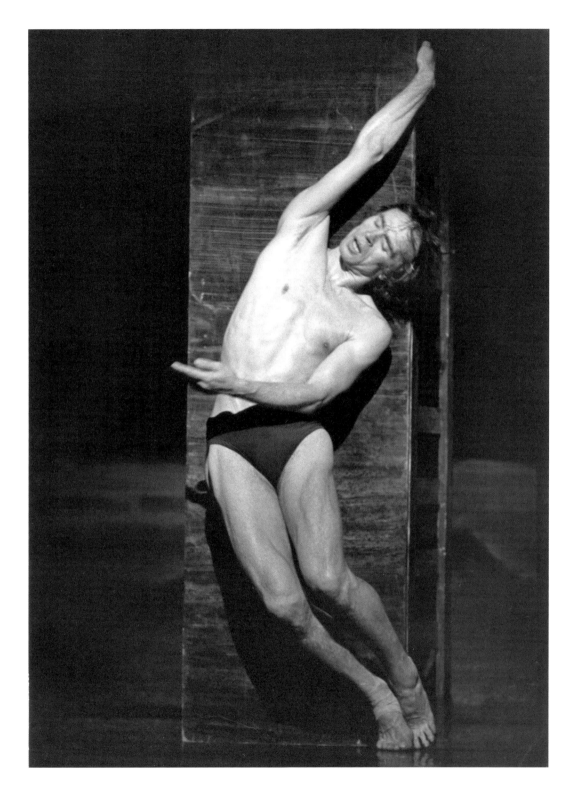

The Prodigal Son, 1973

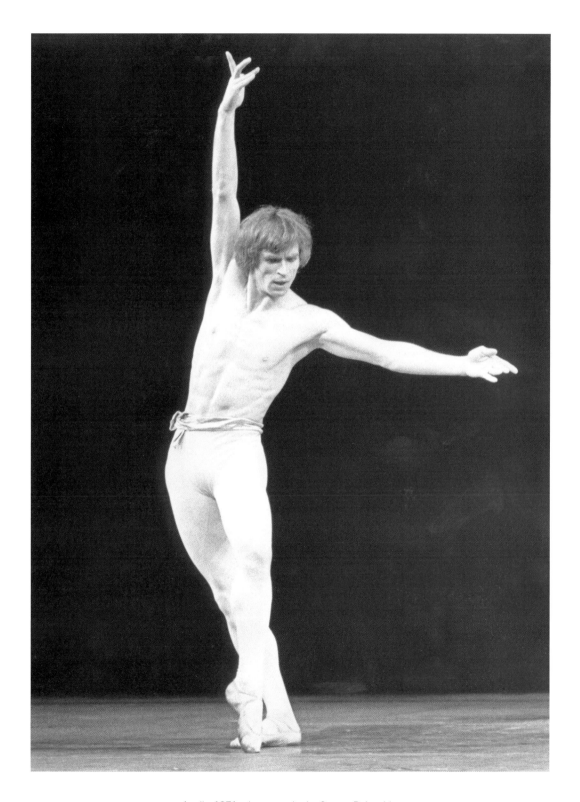

Apollo, 1971, choreography by George Balanchine

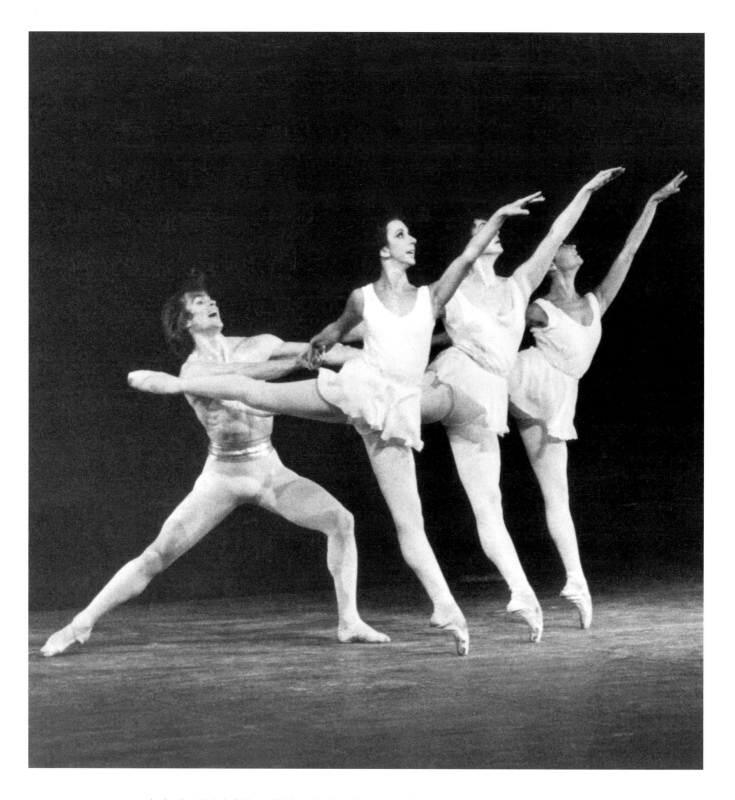

As Apollo with Lois Strike as Polyhymnia, Lynn Seymour as Terpsichore and Anya Evans as Calliope
in *Apollo,* Sadler's Wells Royal Ballet tour to Israel, 1974

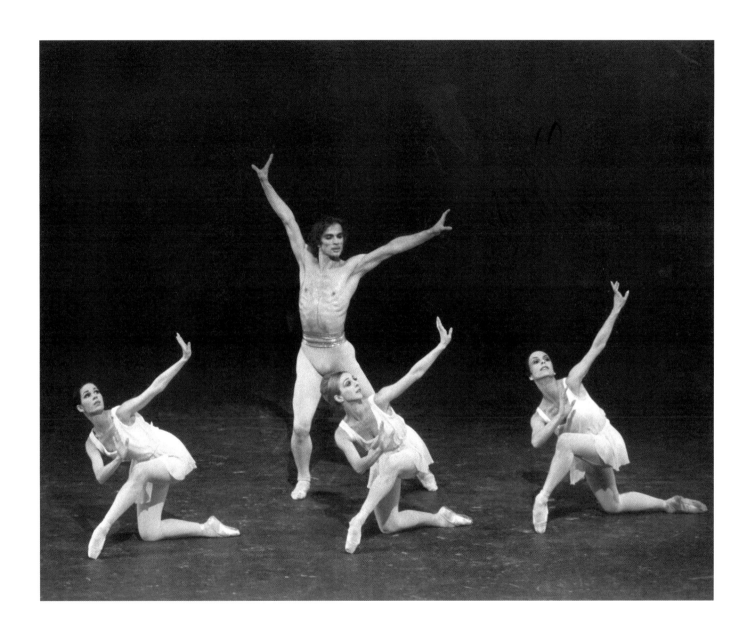

As Apollo with Diana Vere as Calliope, Laura Connor as Polyhymnia and Georgina Parkinson as Terpsichore
in *Apollo,* Metropolitan Opera House New York, The Royal Ballet American tour, 1974

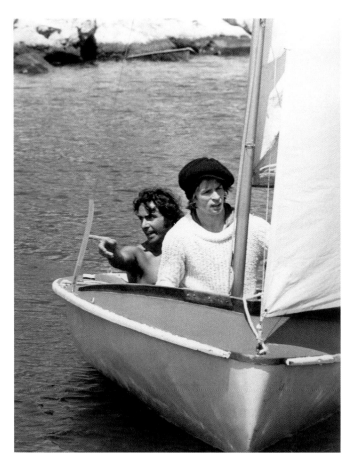 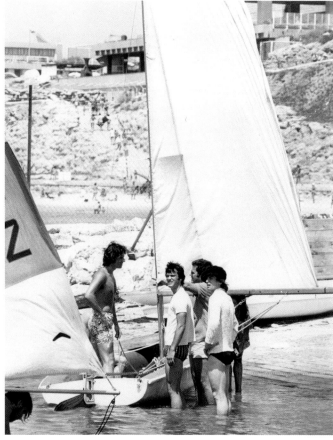

Relaxing on tour: sailing during Sadler's Wells Royal Ballet tour to Israel, 1974;
Stephen Jefferies can be seen in the centre of the photograph on the right

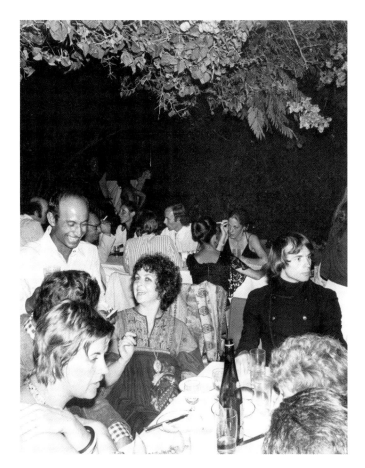

left: dinner with Lynn Seymour (centre), Sadler's Wells Royal Ballet tour to Israel, 1974
right: party in St Louis during The Royal Ballet American tour, August 1969

CHOREOGRAPHERS OF THE ROYAL BALLET: FREDERICK ASHTON, JOHN CRANKO, NINETTE DE VALOIS, ROBERT HELPMANN, KENNETH MACMILLAN

Nureyev danced as many different roles as he could with The Royal Ballet and had works created for him by the Company's two most prolific choreographers Frederick Ashton and Kenneth MacMillan.

Nureyev had asked Ashton, Founder Choreographer of The Royal Ballet, to create the solo *Poème tragique* in which he made his debut on the London stage. It was to be Ashton who set the seal on the great partnership of Fonteyn and Nureyev when he created *Marguerite and Armand* for them in 1963. The story of *The Lady of the Camellias* told in one of Ashton's masterly one-act distillations, provided perfect roles for Nureyev as the romantic, headstrong Armand and Fonteyn as the tragic Marguerite. They were supported by Michael Somes as Armand's father and Leslie Edwards as the Duke. The four dancers were to give 41 performances of the work with The Royal Ballet between 1963 and 1973. No other dancers performed the work during Fonteyn and Nureyev's lifetimes.

In 1968 Ashton created *Jazz Calendar,* to the score by Richard Rodney Bennett and with designs by Derek Jarman. The ballet was notable for the languorous and sultry *Friday pas de deux* created for Nureyev and Antoinette Sibley.

Other Ashton roles Nureyev danced in revivals included Colas in *La Fille mal gardée* and Oberon in *The Dream.* He also appeared in revivals of works by other Royal Ballet choreographers. In 1963 he was Etiocles in John Cranko's *Antigone,* in 1964 he was a moody, brooding Hamlet in the work by Robert Helpmann and in 1971, he was the First Red Knight in Ninette de Valois' ballet *Checkmate.*

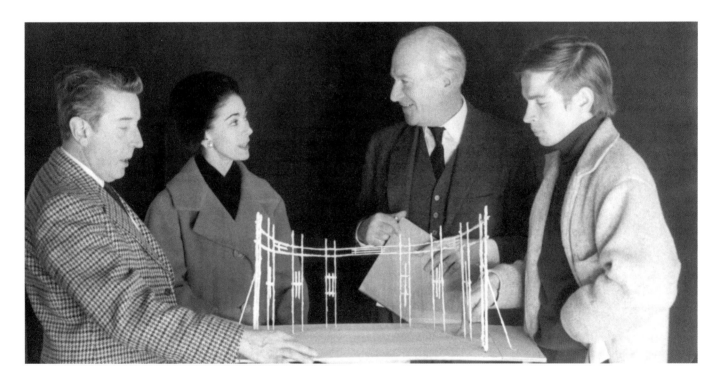

left to right: Frederick Ashton, Margot Fonteyn, Cecil Beaton and Rudolf Nureyev with the model set for *Marguerite and Armand,* 1963

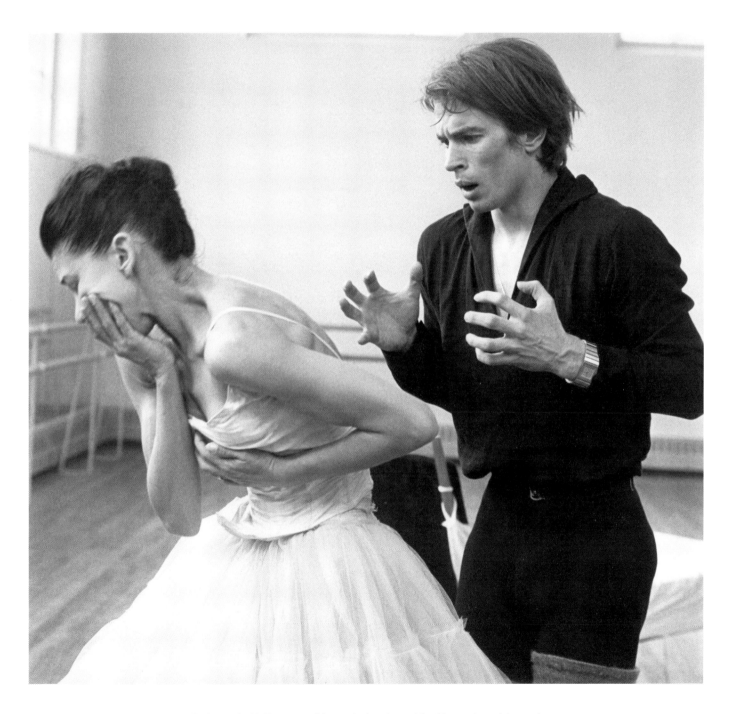

As Armand with Fonteyn as Marguerite in rehearsal for *Marguerite and Armand,*
choreography by Frederick Ashton, 1963

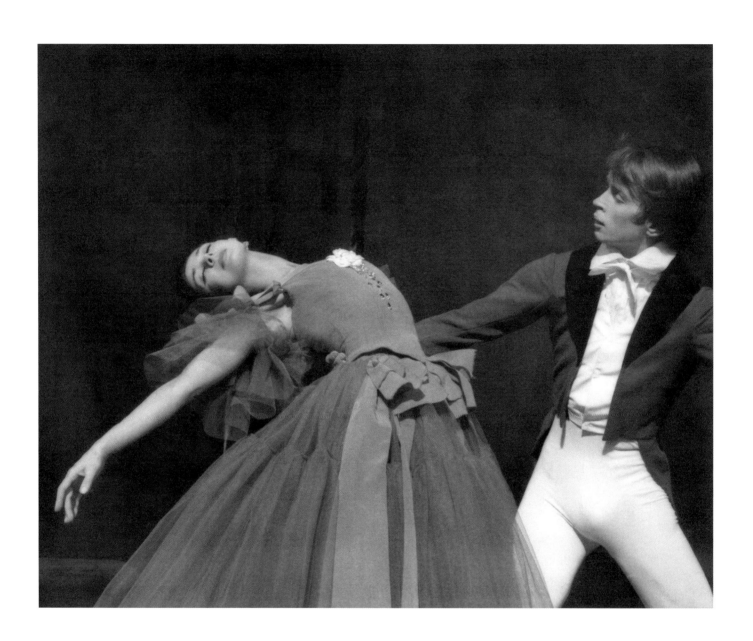

above and opposite: As Armand with Fonteyn as Marguerite in *Marguerite and Armand,* 1963

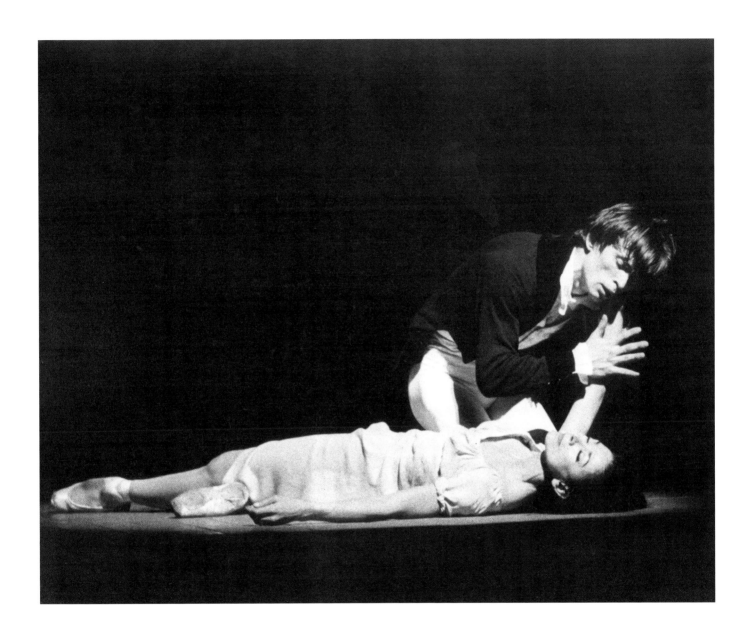

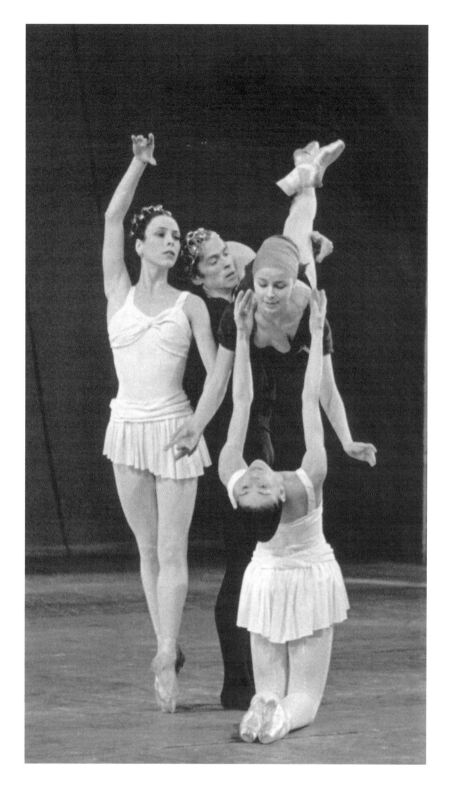

left to right: Georgina Parkinson, Nureyev, Ann Jenner and Margot Fonteyn (kneeling) in rehearsal for *Symphonic Variations,* 1963, choreography by Frederick Ashton

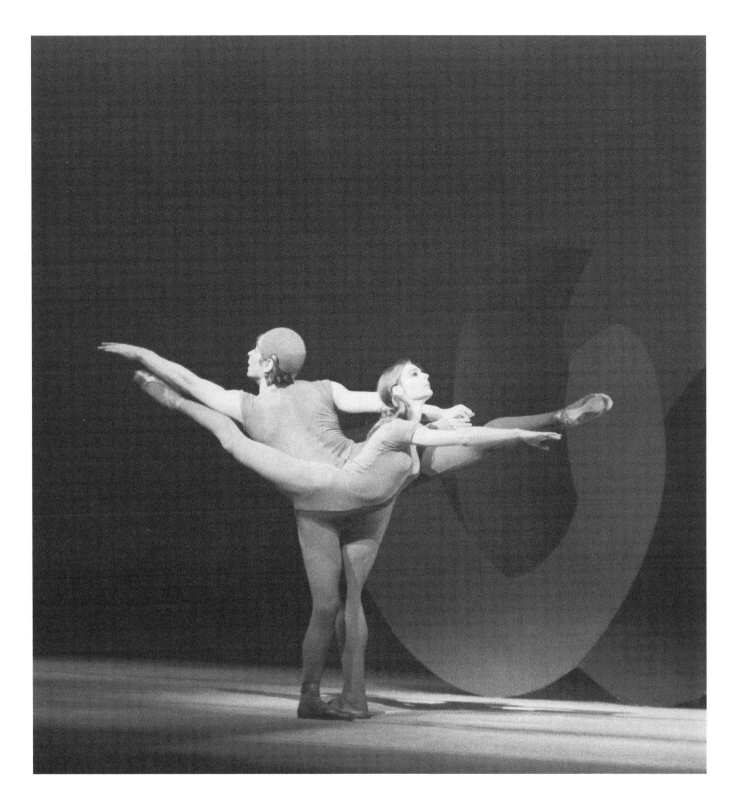

Friday with Antoinette Sibley in *Jazz Calendar,* choreography by Frederick Ashton, 1968

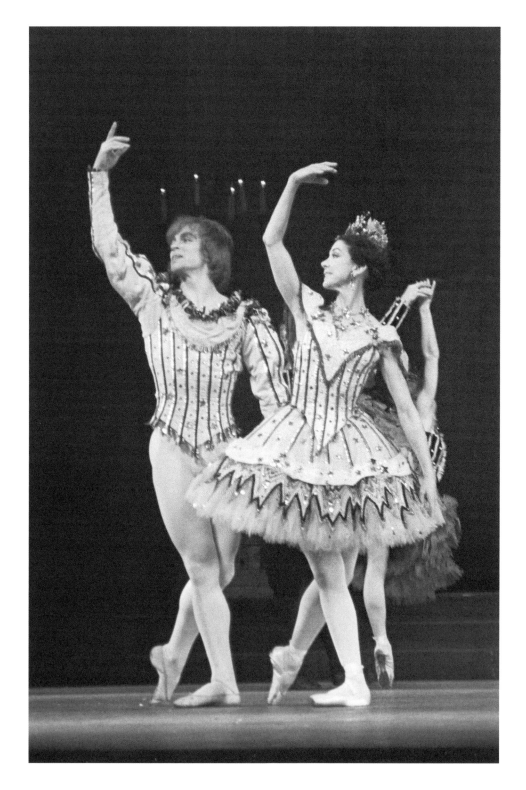

With Fonteyn in *Birthday Offering,* 1968, choreography by Frederick Ashton

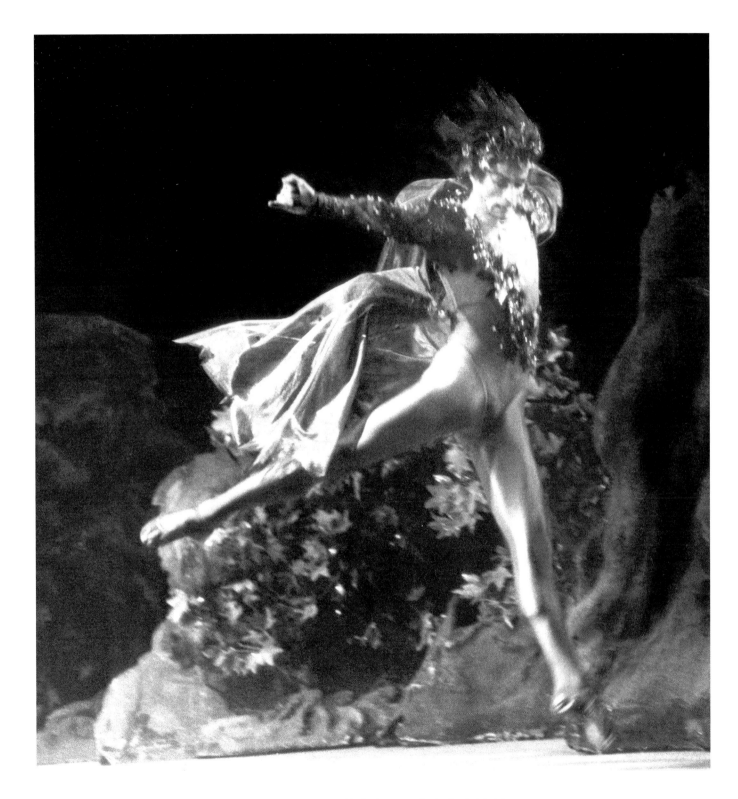

As Oberon in *The Dream*, 1976, choreography by Frederick Ashton

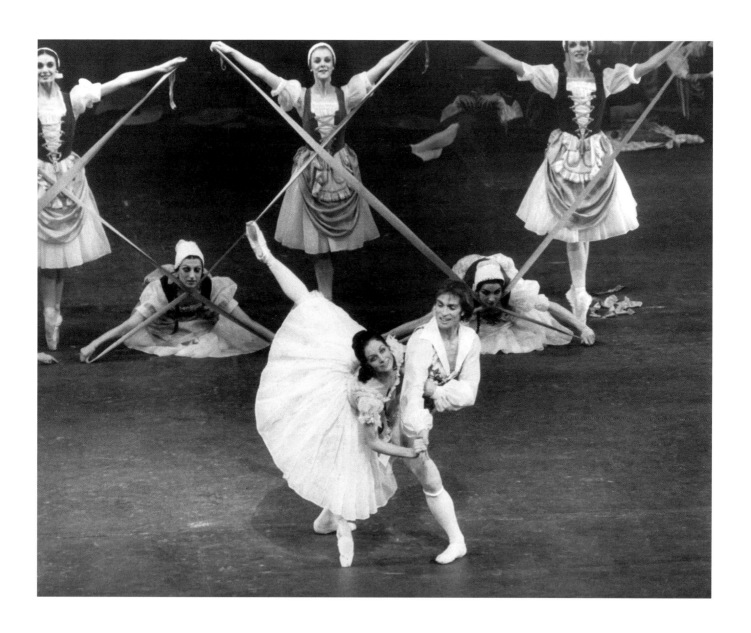

As Colas with Merle Park as Lise and Artists of The Royal Ballet
in *La Fille mal gardée,* Metropolitan Opera House New York, The Royal Ballet American tour, 1974

As Colas with Artists of The Royal Ballet in *La Fille mal gardée,*
Metropolitan Opera House New York, The Royal Ballet American tour, 1974

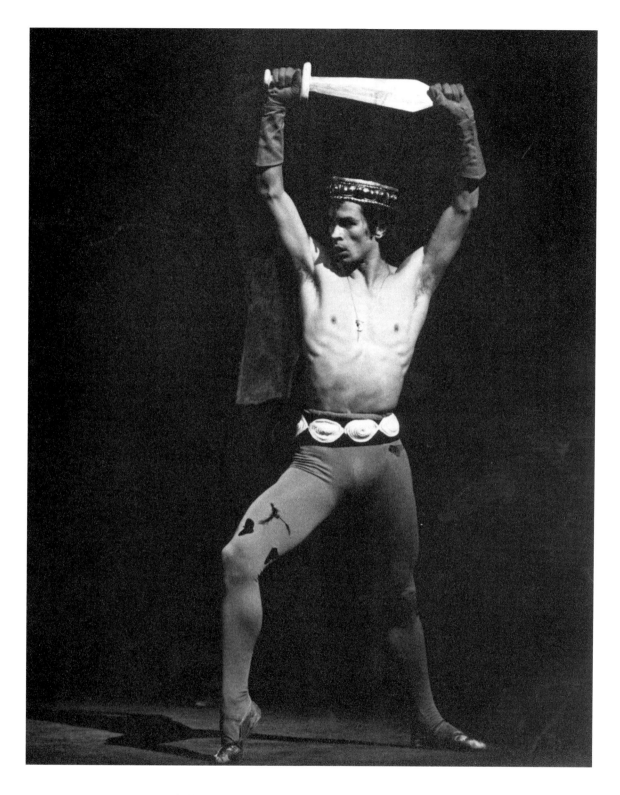

As Etiocles in *Antigone,* 1962, choreography by John Cranko

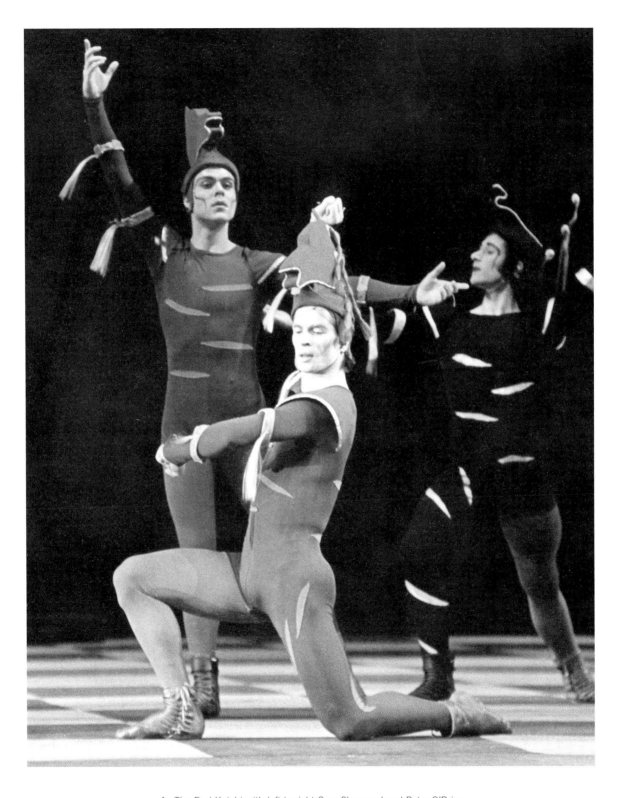

As The Red Knight with left to right Gary Sherwood and Peter O'Brien
in *Checkmate*, 1971, choreography by Ninette de Valois

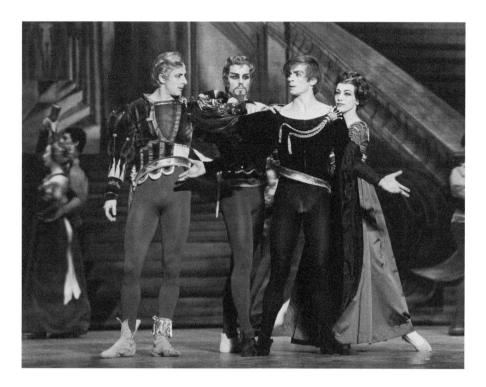

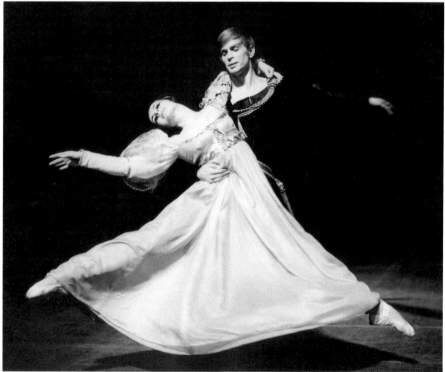

above: left to right: David Drew as Laertes, Derek Rencher as King of Denmark,
Nureyev as Hamlet and Monica Mason as Queen of Denmark in *Hamlet,* 1964, choreography by Robert Helpmann
below: As Hamlet with Lynn Seymour as Ophelia in *Hamlet,* 1964

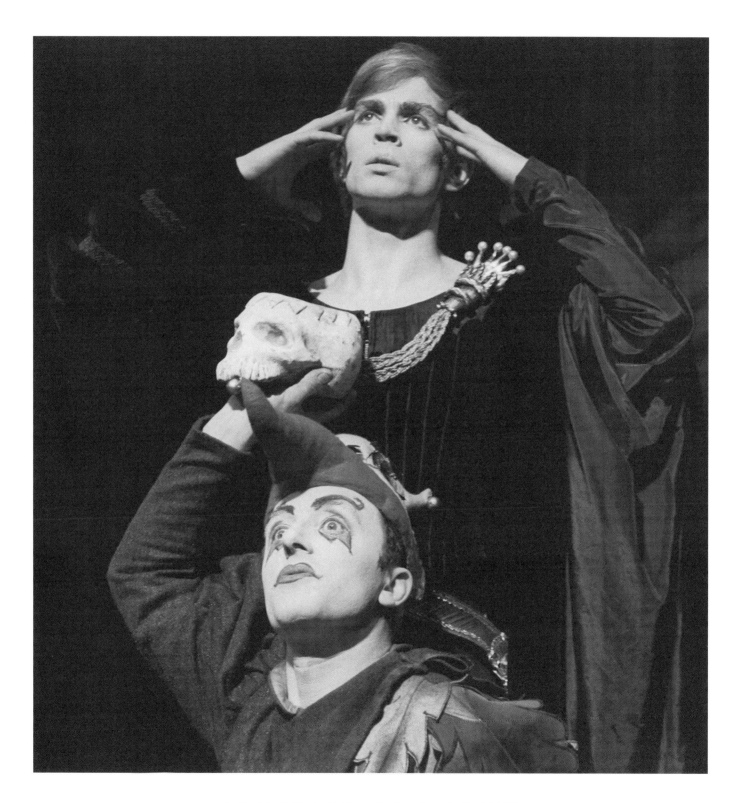

As Hamlet with Stanley Holden as the Gravedigger in *Hamlet,* 1964

Kenneth MacMillan, Principal Choreographer of The Royal Ballet, was just beginning to flex his choreographic muscles in the 1960s with the young Lynn Seymour as his muse. In 1964 he created *Two Loves I Have* in *Images of Love* on Nureyev, Seymour and Christopher Gable, who regularly partnered Seymour. In 1965 MacMillan created the first of his great three-act ballets *Romeo and Juliet* working with Seymour and Gable, as well as teaching the roles to several other couples including Nureyev and Fonteyn. The first night performance was danced by Nureyev and Fonteyn and they danced it together until 1976. Nureyev also danced it with other Royal Ballet ballerinas including Seymour and Merle Park, as well as with guest artist Natalia Makarova.

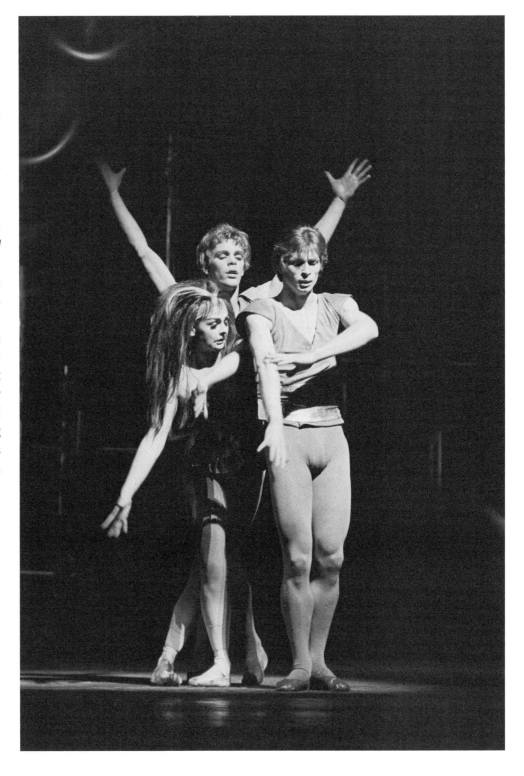

With Lynn Seymour and Christopher Gable
in *Two Loves I Have* in *Images of Love,*
choreography by Kenneth MacMillan, 1964

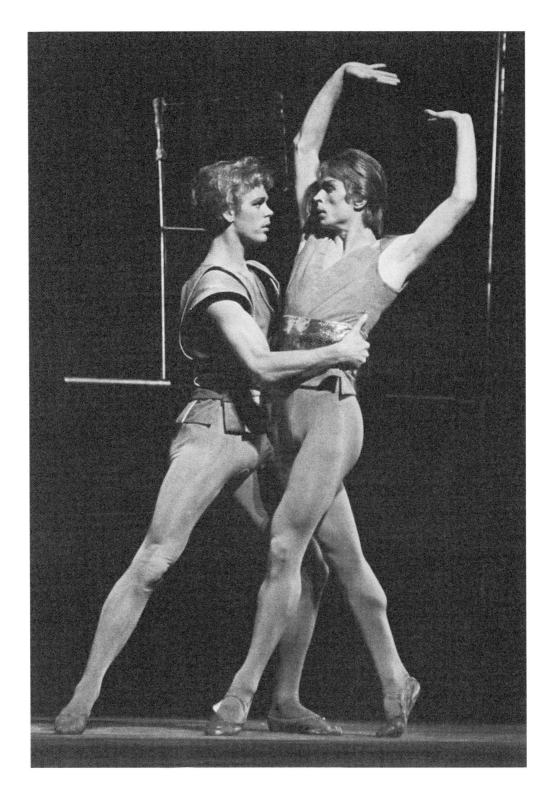

With Christopher Gable in *Two Loves I Have* in *Images of Love*, 1964

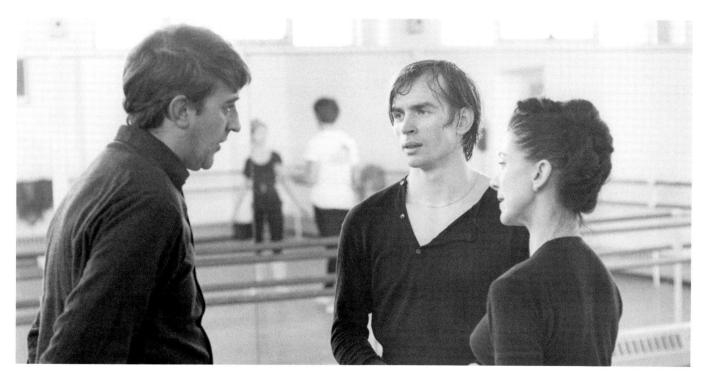

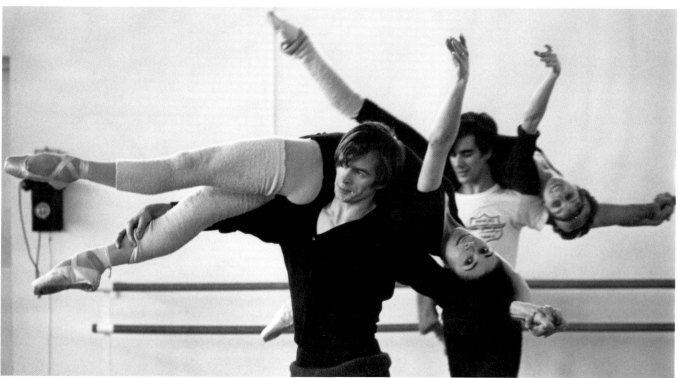

Rehearsals for *Romeo and Juliet,* choreography by Kenneth MacMillan, 1965
above: With MacMillan and Fonteyn
below: With Fonteyn, mirrored by Donald MacLeary and Merle Park

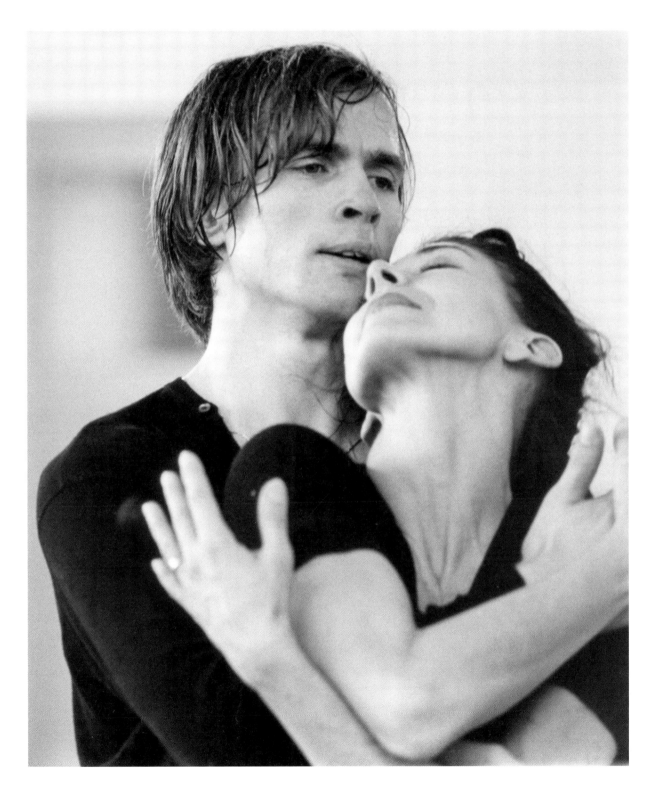

As Romeo with Fonteyn as Juliet in rehearsal for *Romeo and Juliet*, 1965

left to right: Anthony Dowell as Benvolio, David Blair as Mercutio and Nureyev as Romeo
with Artists of The Royal Ballet in Act I of *Romeo and Juliet,* 1965

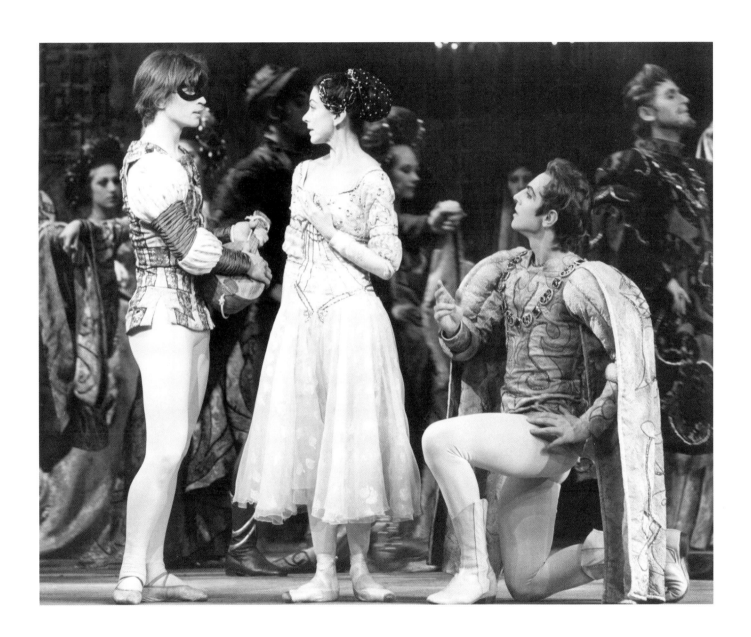

As Romeo with Fonteyn as Juliet and Derek Rencher as Paris in Act I of *Romeo and Juliet,* 1965

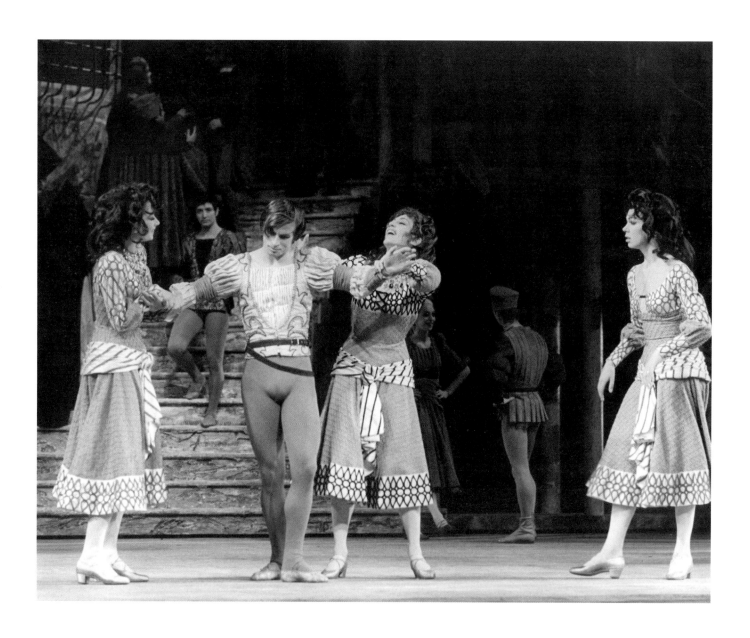

As Romeo with left to right Deanne Bergsma, Monica Mason and Carole Needham
as the Harlots in Act II of *Romeo and Juliet,* 1965

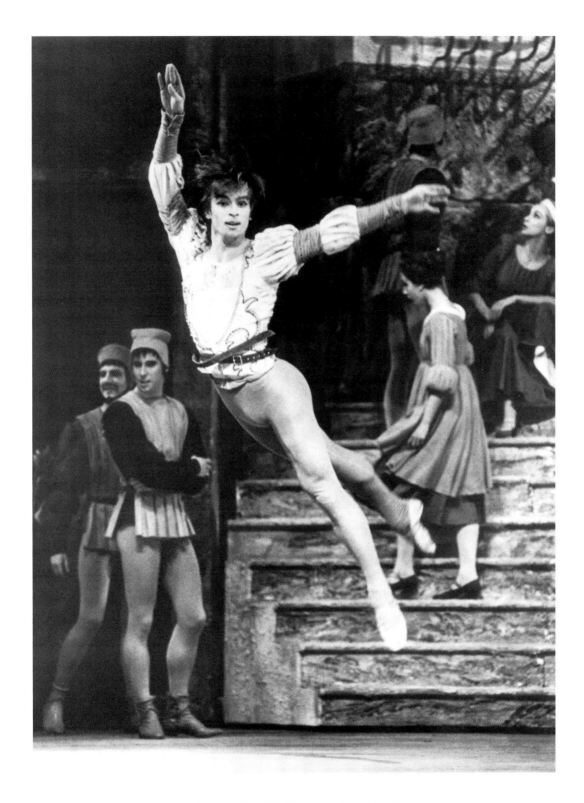

As Romeo in Act II of *Romeo and Juliet,* 1965

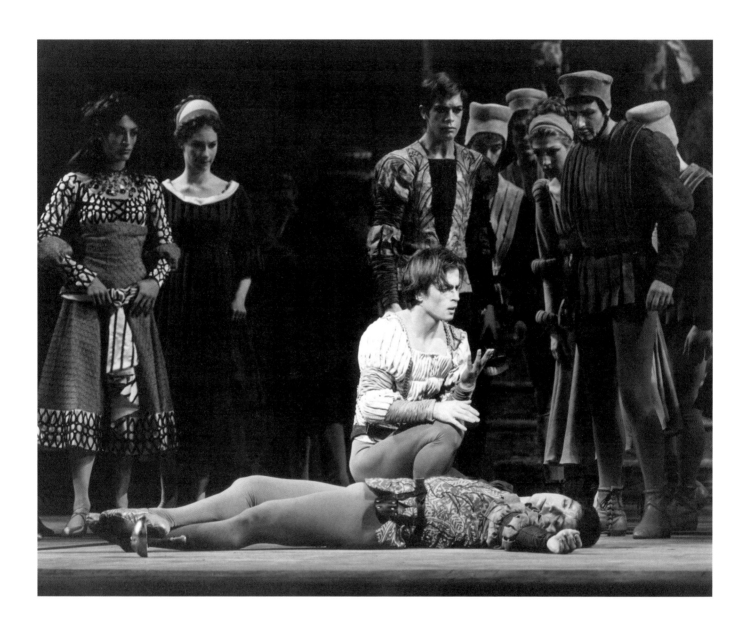

As Romeo with Blair as Mercutio and Artists of The Royal Ballet
in Act II of *Romeo and Juliet,* 1965

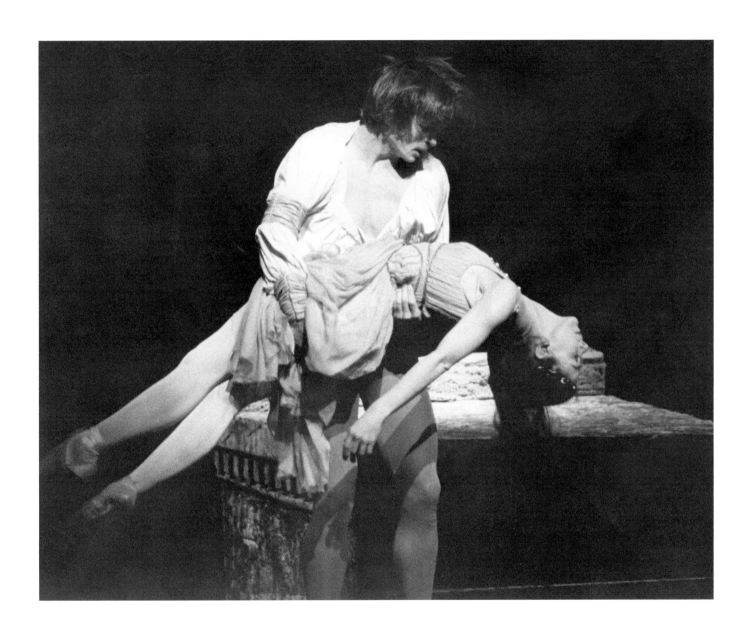

As Romeo with Fonteyn as Juliet in Act III of *Romeo and Juliet,* 1965

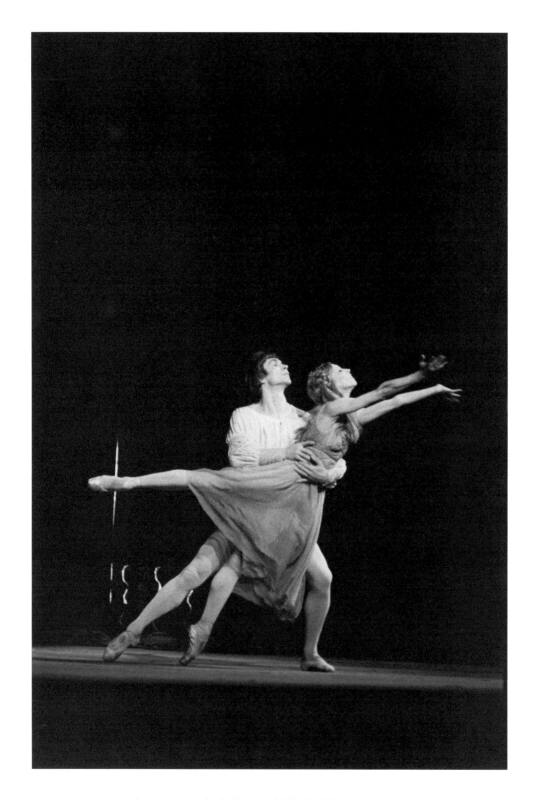

above and opposite: As Romeo with Natalia Makarova as Juliet
in *Romeo and Juliet,* 1973

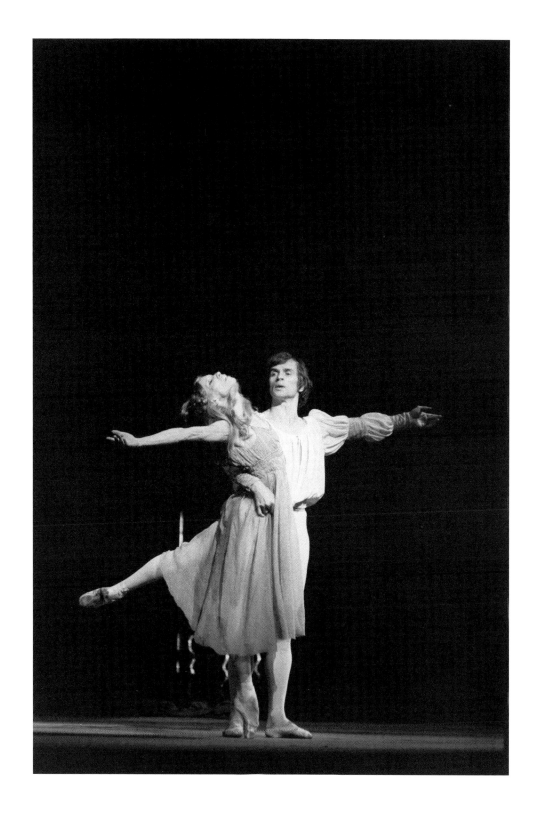

Nureyev was great friends with Lynn Seymour. Among other things they shared an irreverent sense of humour and in 1972 MacMillan created the comic *pas de deux Sideshow* for them in which they played two characters from the circus. Nureyev was the egotistical strongman and Seymour the dizzy equestrienne. Other MacMillan roles Nureyev danced include Des Grieux in *Manon* and The Messenger of Death in *Song of the Earth*.

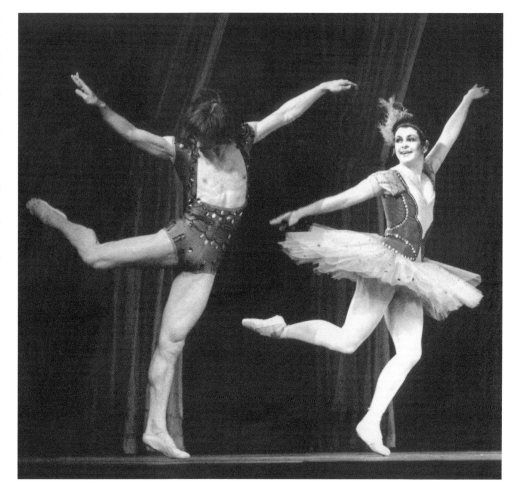

above and opposite: With Lynn Seymour
in *Sideshow,* choreography by Kenneth MacMillan, 1972

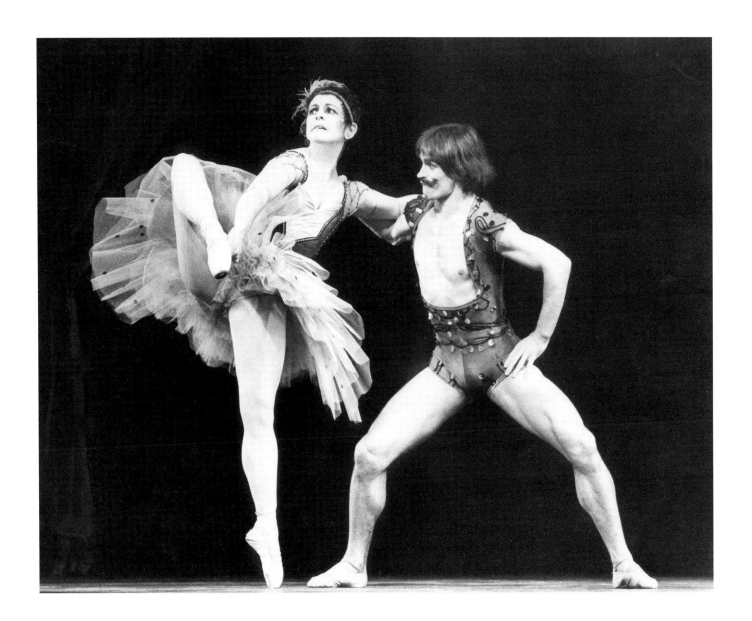

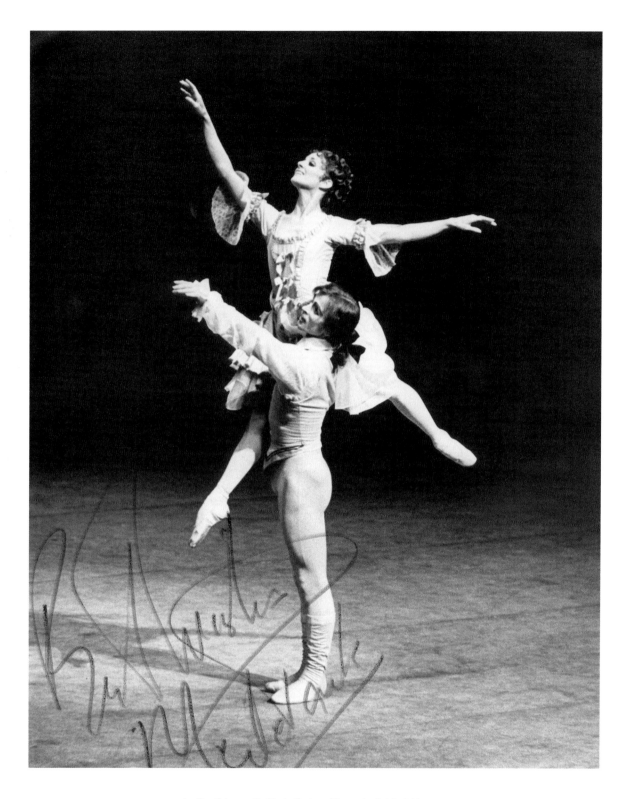

As Des Grieux with Merle Park as Manon in Act I of *Manon*,
Metropolitan Opera House New York, The Royal Ballet American tour, 1974,
choreography by Kenneth MacMillan

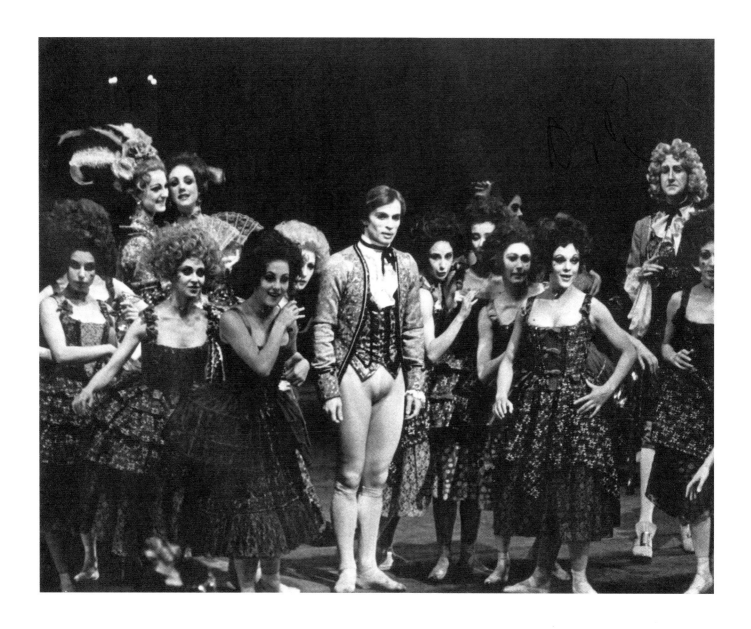

As Des Grieux with Artists of The Royal Ballet in Act II of *Manon*,
Metropolitan Opera House New York, The Royal Ballet American tour, 1974

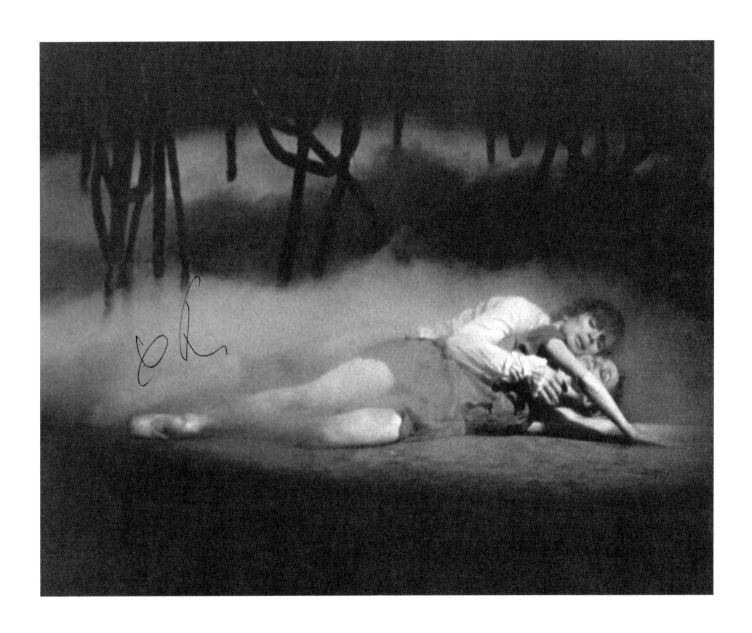

As Des Grieux with Park as Manon in Act III of *Manon,*
Metropolitan Opera House New York, The Royal Ballet American tour, 1974

MODERN CHOREOGRAPHERS
GEORGE BALANCHINE, ROLAND PETIT, RUDI VAN DANTZIG, GLEN TETLEY, JEROME ROBBINS, JOHN NEUMEIER, MAURICE BÉJART

Nureyev was always interested in pushing back the boundaries of ballet, particularly for male dancers. He wanted to experience as wide a range of choreographic styles as possible. Modern ballet choreographers he worked with at The Royal Ballet included Roland Petit, Rudi van Dantzig and Jerome Robbins.

Roland Petit created two ballets for Nureyev and Fonteyn and The Royal Ballet. The sight of Nureyev emerging and disappearing into a Daliesque mouth was one of the talking points of the Petit ballet *Paradise Lost*!

Kenneth MacMillan, as Director of The Royal Ballet, invited Jerome Robbins to work with the Company. Nureyev appeared in two of his ballets. *Dances at a Gathering* epitomises a golden moment in The Royal Ballet's history. When Nureyev erupted into the Company's midst in the 1960s, there was a group of young dancers who would never be the same again. For male dancers, such as Anthony Dowell, Christopher Gable, David Wall and Michael Coleman, he pushed back the boundaries of what was possible and

firmly established male ballet dancers centre stage, at the same time as showing them that they could be sexy. For the women dancers he partnered, such as Monica Mason, Lynn Seymour and Antoinette Sibley, in the words of Mason, 'Dancing with Rudolf was like dancing on the edge of a cliff.'

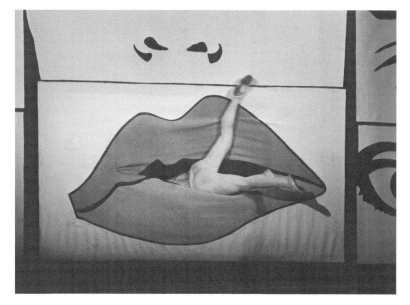

Robbins chose these dancers along with Nureyev when he came to cast his ballet. The individual qualities of the dancers as well as the obvious affection and close relationships between them lifted the work onto another plane. Nureyev also appeared with Jennifer Penney in *Afternoon of a Faun,* Robbins' reinterpretation of the Nijinsky ballet.

Not content just to explore modern ballets, Nureyev was the first classically trained dancer to work with modern dance choreographers and companies. It is hard to appreciate just how extraordinary a leap this was in the 1960s but by the 1970s The Royal Ballet was inviting modern dance choreographers such as Glen Tetley to work with the two Companies.

Paradise Lost, choreography by Roland Petit, 1967

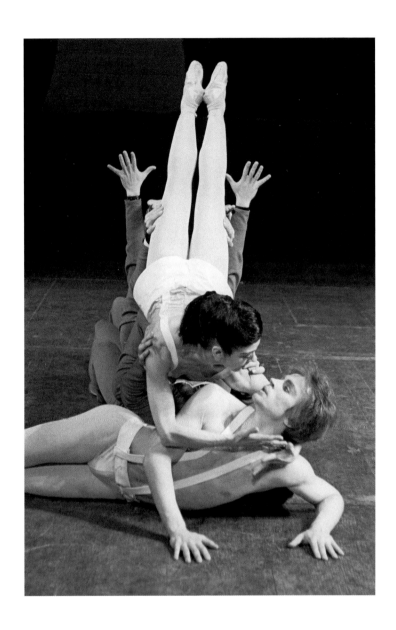

above and opposite: With Fonteyn in *Paradise Lost,* 1967

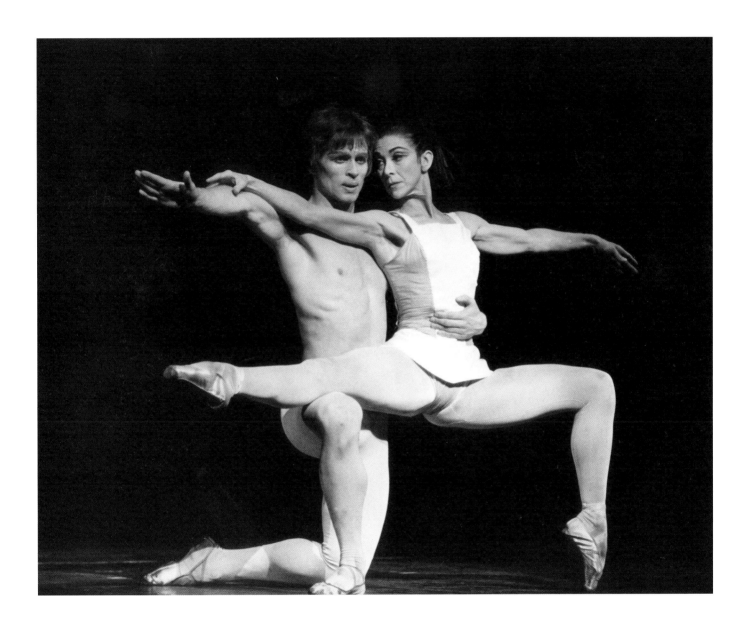

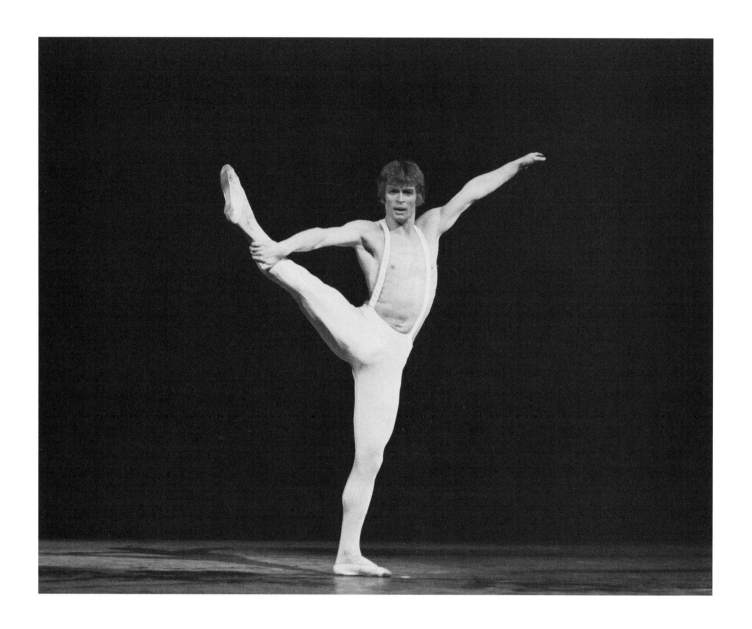

Paradise Lost, 1967

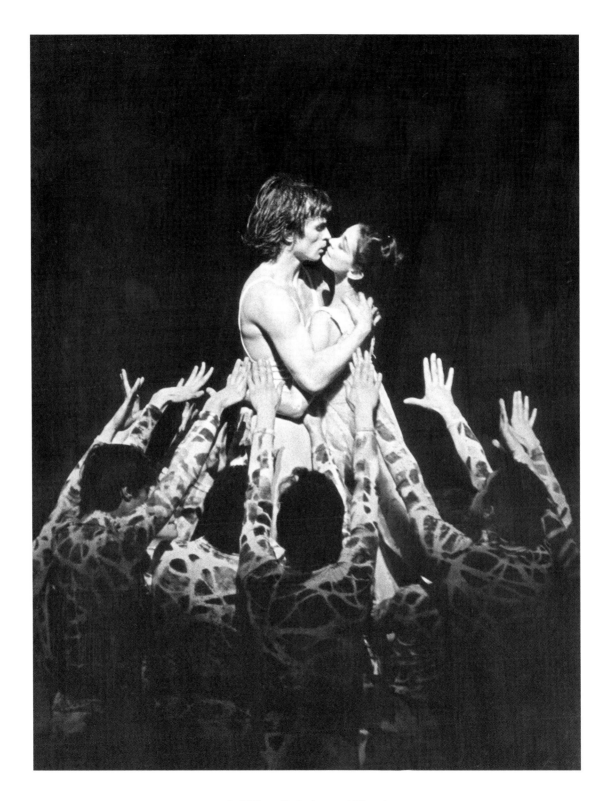

As Pélléas with Fonteyn as Mélisande
in *Pélléas et Mélisande,* choreography by Roland Petit, 1969

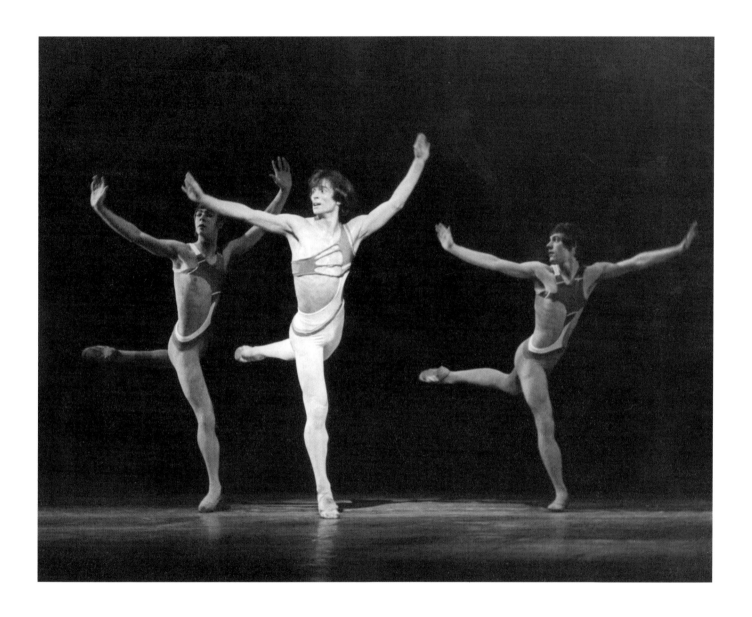

As The Traveller with David Ashmole *(left)* and Graham Fletcher *(right)*
in *The Ropes of Time,* choreography by Rudi van Dantzig, 1970

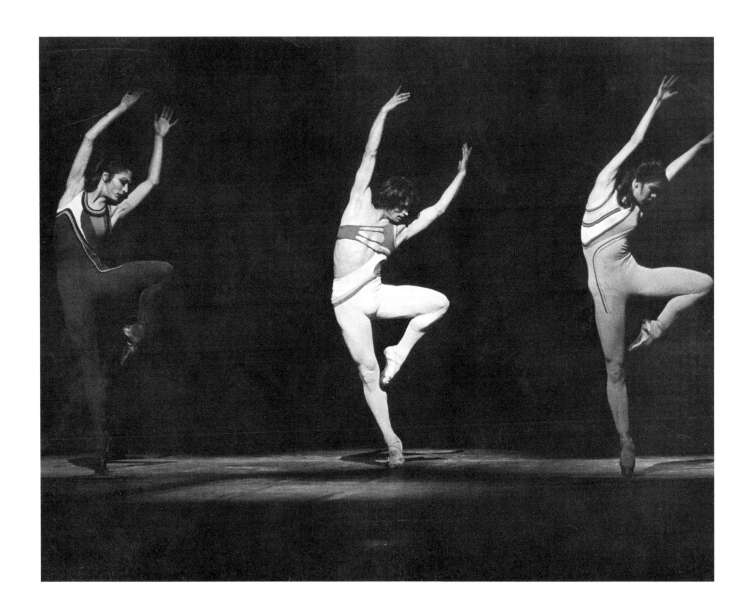

As The Traveller with Monica Mason *(left)* as Death and Diana Vere *(right)*
as Life in *The Ropes of Time*, 1970

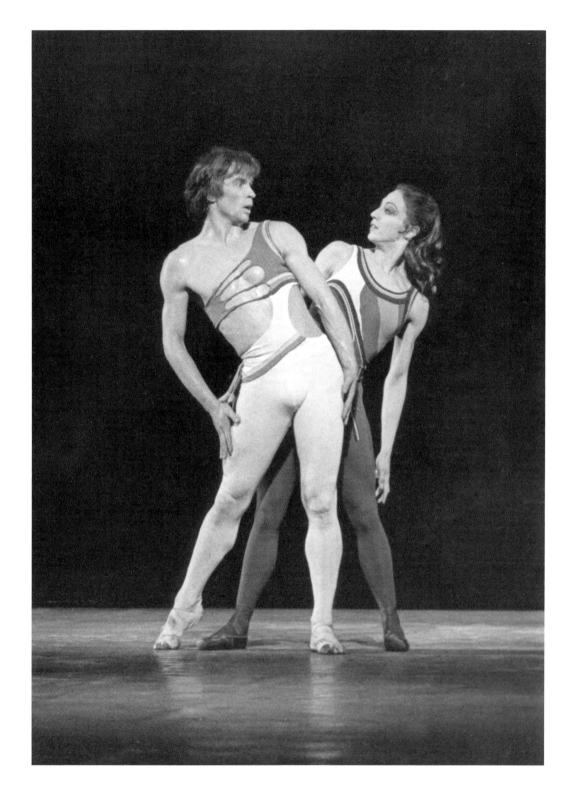

As The Traveller with Monica Mason as Death in *The Ropes of Time*, 1970

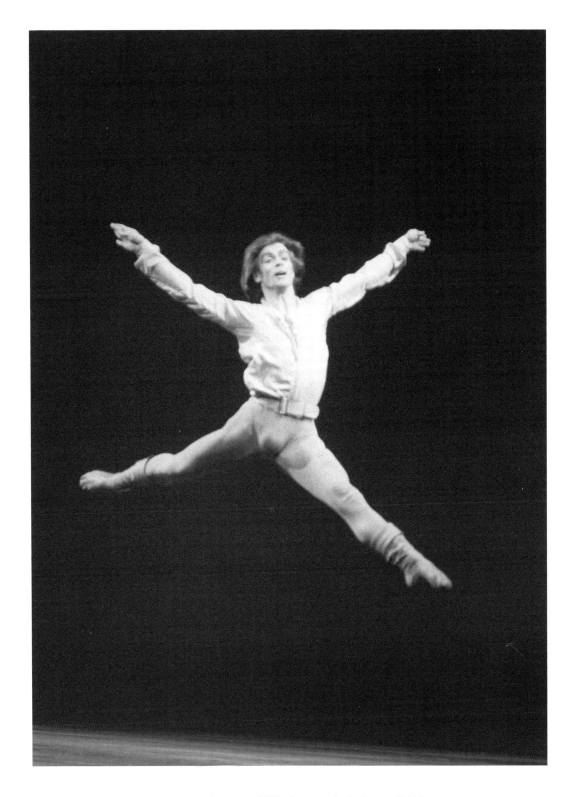

Dances at a Gathering, 1970, choreography by Jerome Robbins

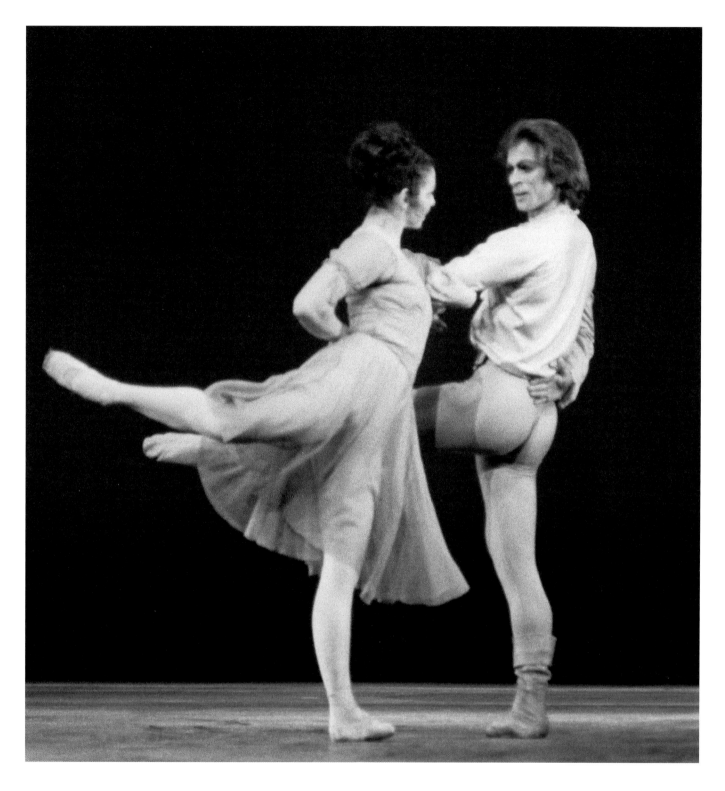

With Lynn Seymour in *Dances at a Gathering,* 1970

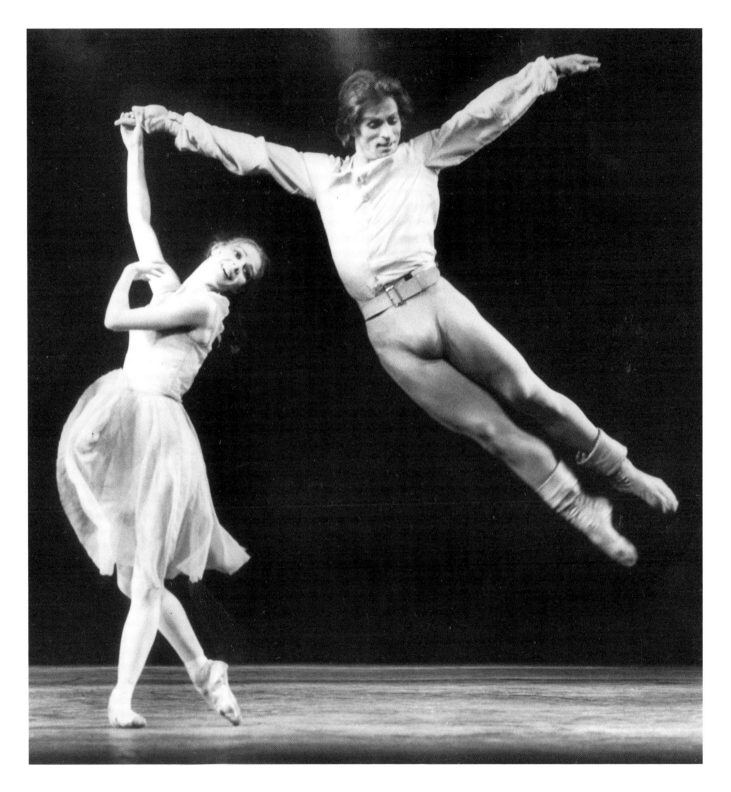

With Antoinette Sibley in *Dances at a Gathering,* 1970

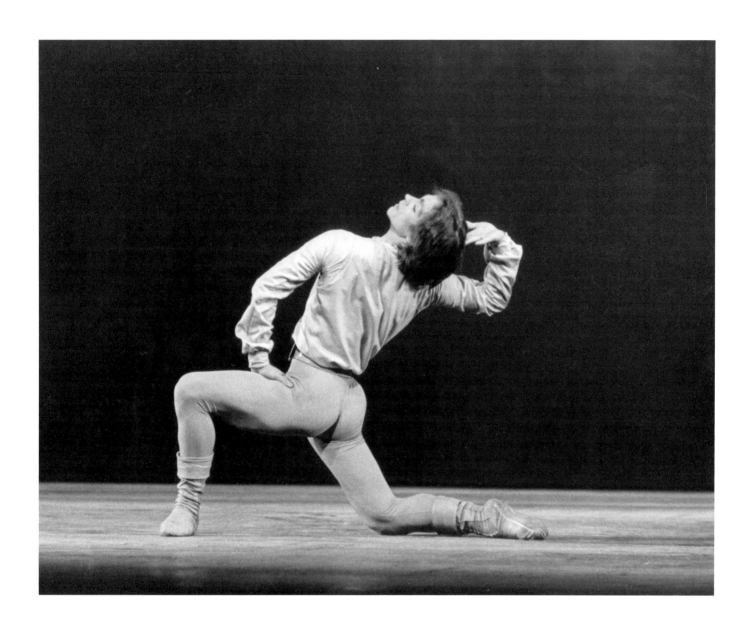

Dances at a Gathering, 1970

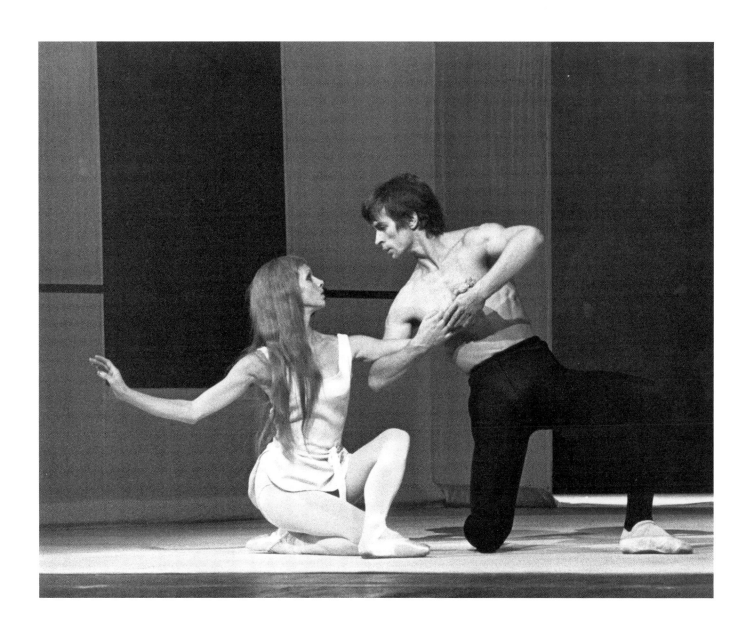

With Jennifer Penney in *Afternoon of a Faun,* 1972
choreography by Jerome Robbins

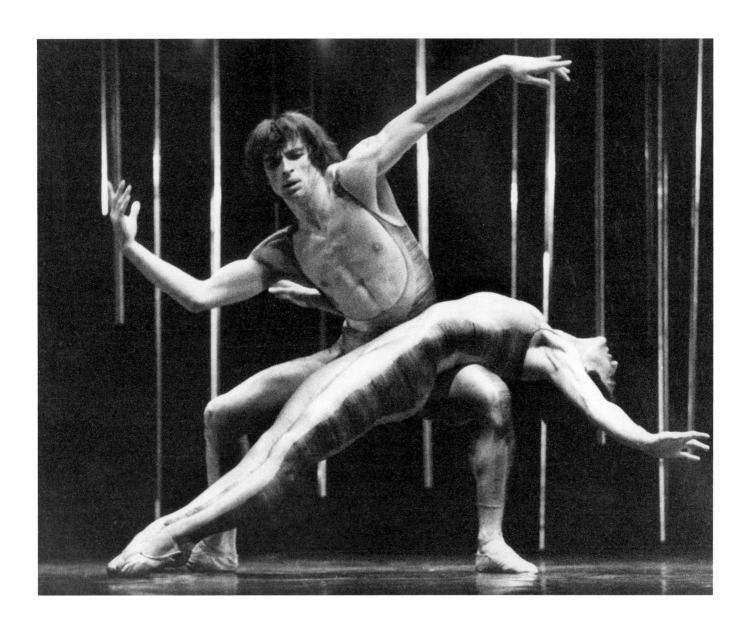

With Monica Mason in *Field Figures,* 1972, choreography by Glen Tetley

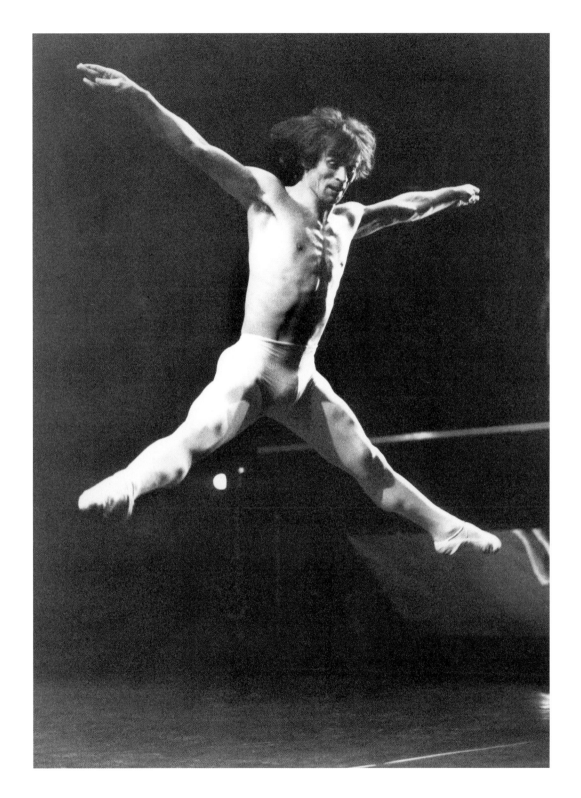

Laborintus, choreography by Glen Tetley, 1972

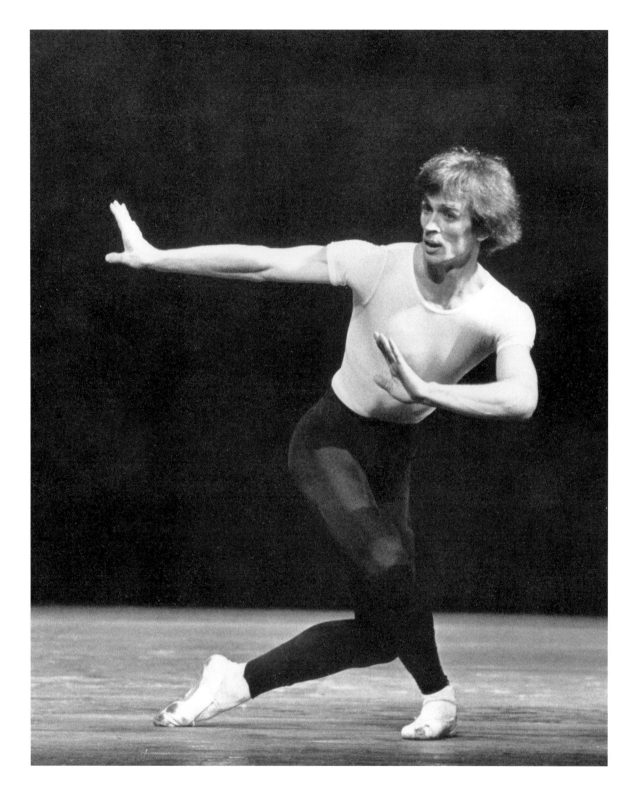

Agon, 1973, choreography by George Balanchine

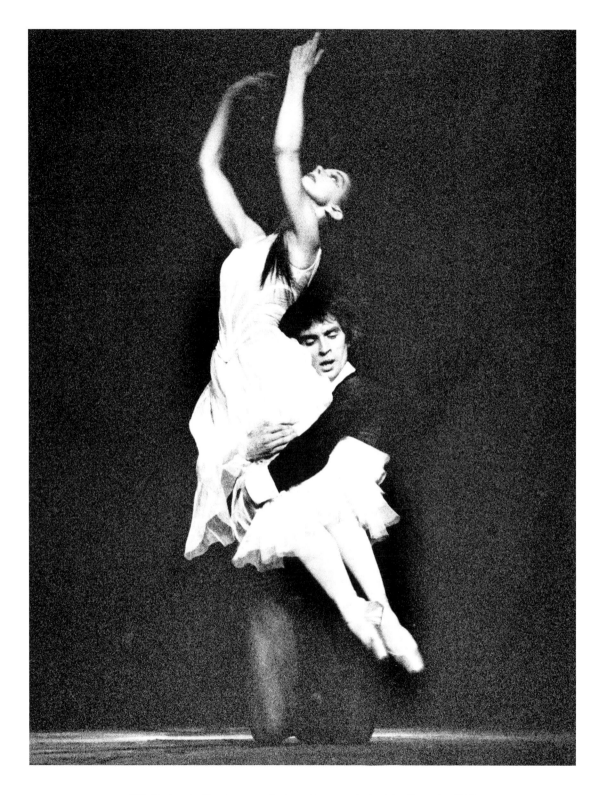

With Fonteyn in *Don Juan pas de deux*, choreography by John Neumeier, 1975

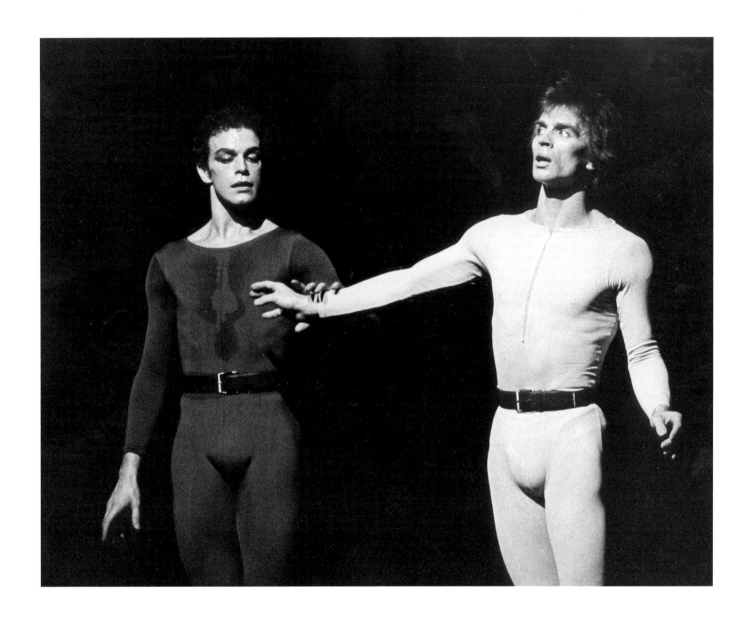

above and opposite: With Anthony Dowell in *Chant du compagnon errant,* 1975,
choreography by Maurice Béjart

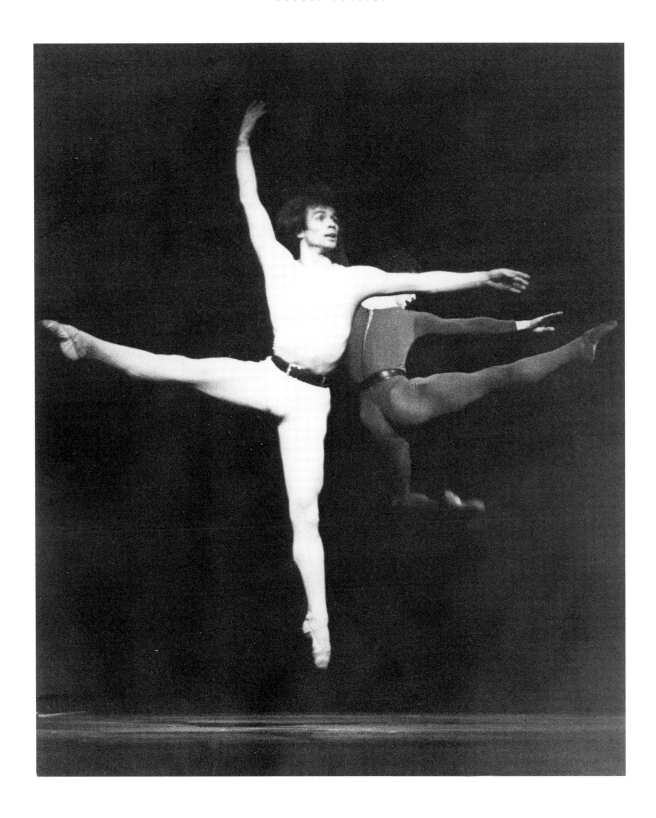

RUDOLF NUREYEV'S PRODUCTIONS FOR THE ROYAL BALLET

LA BAYADÈRE

Nureyev made his debut in the West as a member of the Kirov Ballet in *The Kingdom of the Shades* scene from *La Bayadère,* choreographed by Marius Petipa. Two years later, he mounted the work for The Royal Ballet, the first time it had been danced by a Western ballet company. The work provided a wonderful showcase for The Royal Ballet's *corps de ballet* as well as dramatic roles for himself as Solor and Fonteyn as Nikiya. The three soloists were the young ballerinas Lynn Seymour, Monica Mason and Merle Park. The ballet was a great success and remained in the repertory. Nureyev returned to dance it over the years with Fonteyn, Antoinette Sibley, Svetlana Beriosova, Merle Park, Lesley Collier and Bryony Brind. Sadly the work in which he had made his debut in Paris in 1961 was also to be his last ballet. He completed the full-length version for the Paris Opéra on 8 October 1992, his last work before his death on 6 January 1993.

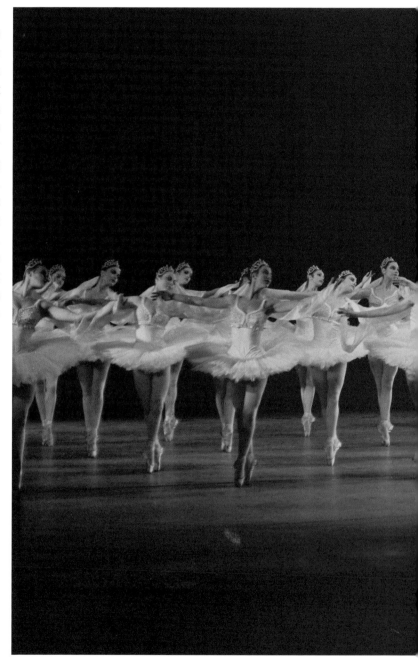

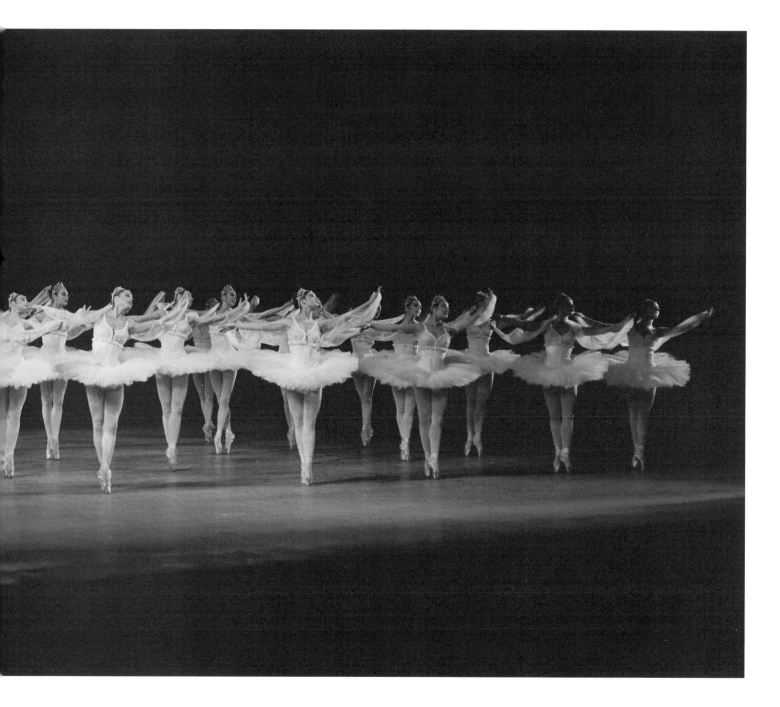

The *corps de ballet* of The Royal Ballet
in *La Bayadère, The Kingdom of the Shades,* 1963

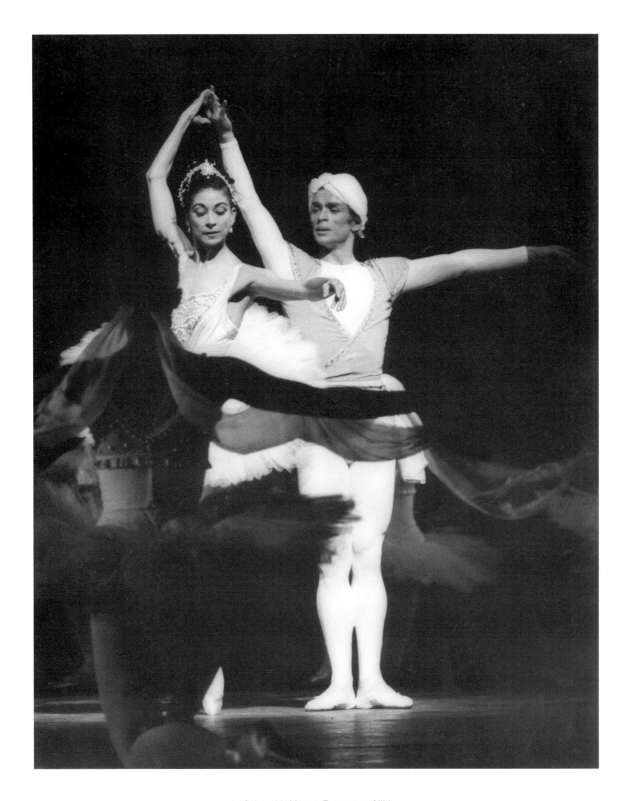

As Solor with Margot Fonteyn as Nikiya
in *La Bayadère, The Kingdom of the Shades,* 1963

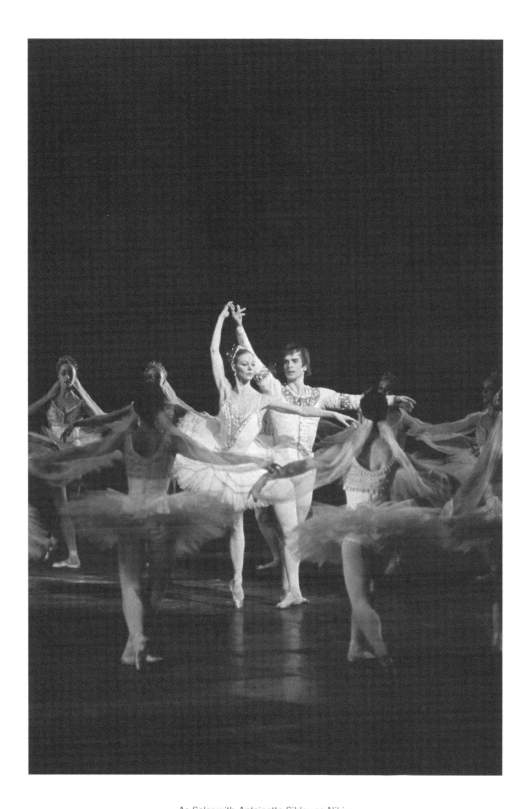

As Solor with Antoinette Sibley as Nikiya
in *La Bayadère, The Kingdom of the Shades,* 1969

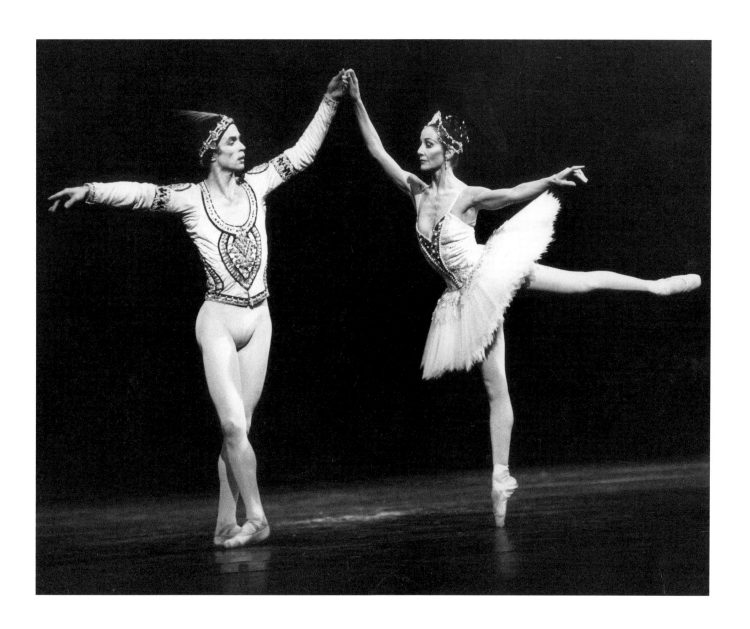

As Solor with Merle Park as Nikiya in *La Bayadère, The Kingdom of the Shades,* 1982

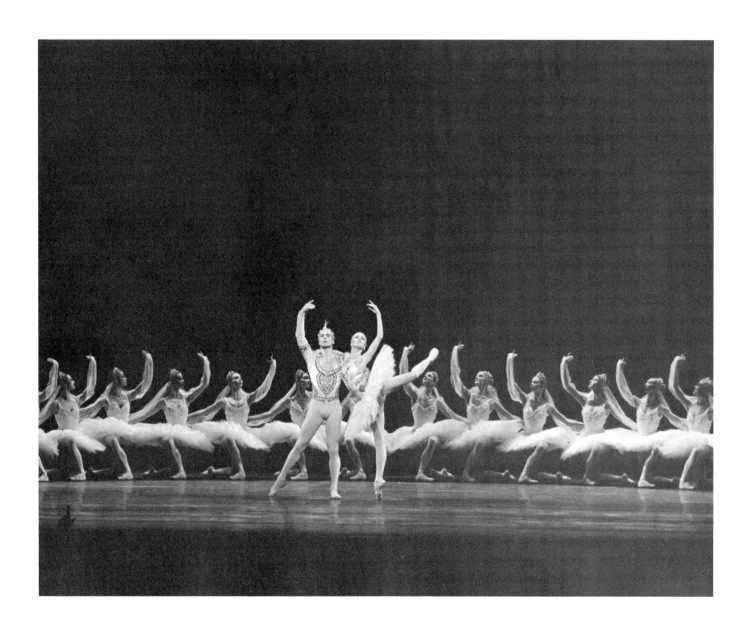

As Solor with Bryony Brind as Nikiya
and the *corps de ballet* of The Royal Ballet
in *La Bayadère, The Kingdom of the Shades,* 1982

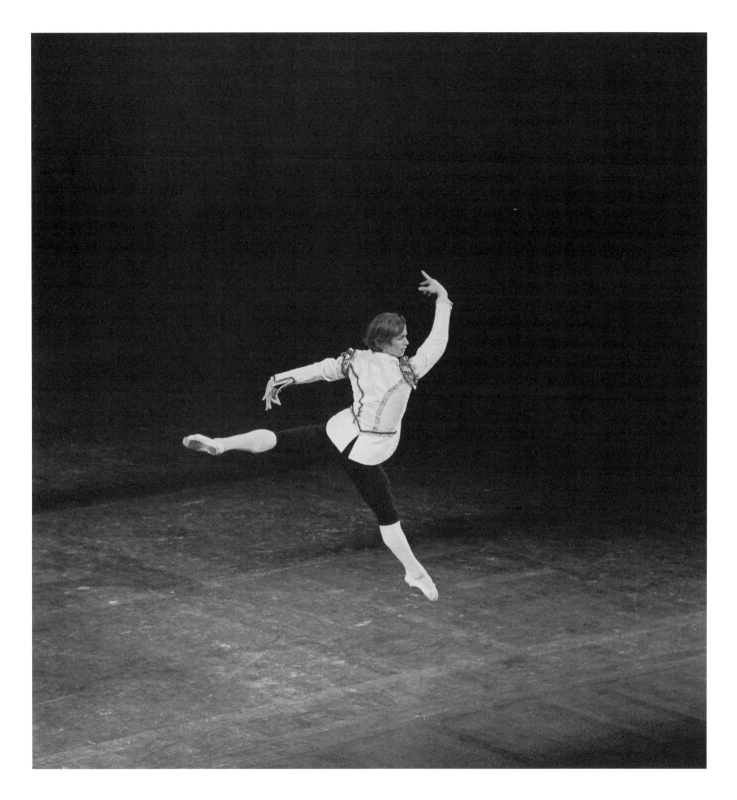

Laurentia pas de six, 1965

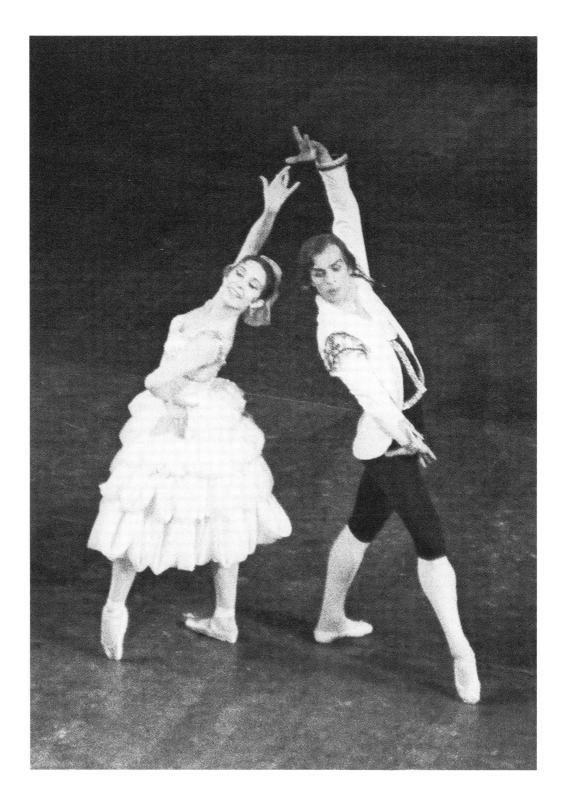

With Nadia Nerina in *Laurentia pas de six*, 1965

THE NUTCRACKER

Nureyev staged his production of *The Nutcracker* for The Royal Ballet in 1968. Nureyev took a psychological approach to the familiar ETA Hoffmann story, treating it very much as a ballet for adults. Clara is danced by a ballerina and the fairy-tale second act becomes her dream, peopled by family and friends. Clara dreams of herself as the ballerina and the kind, old magician Drosselmeyer becomes her Prince. Merle Park created the role of Clara with Nureyev as Herr Drosselmeyer and The Prince at a Gala in aid of The Royal Ballet Benevolent Fund on 29 February 1968. Antoinette Sibley and Anthony Dowell also danced the roles in that first season. The ballet had sumptuous designs by the great theatre designer Nicholas Georgiadis who worked on many of Nureyev's productions. Ninette de Valois often said that the Nureyev production was her favourite version of *The Nutcracker*. Although the story-line and the use of the ballerina as Clara is based on the Gorsky and Vainonen productions with which Nureyev would have been familiar at the Kirov, the choreography, with the exception of the Prince's variation by Vainonen in Act II, is all his own. In a programme note at the time, James Monahan wrote, 'It is all truly classical with an accent (unconscious perhaps) on that noble fluency which is pre-eminently "Kirov" and on that romantic bravura which is distinctly "Rudi".'

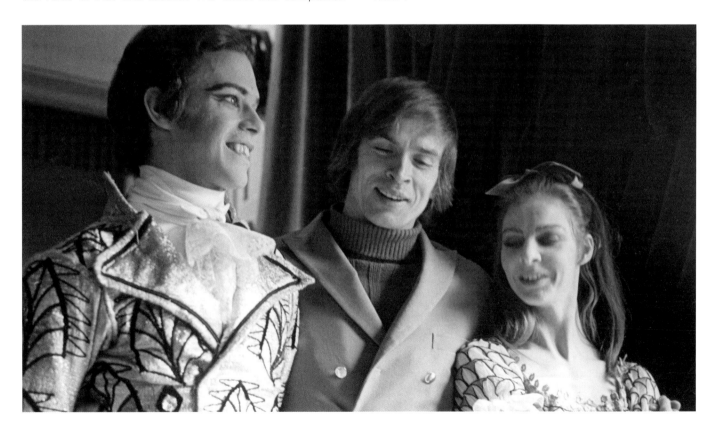

With Anthony Dowell as The Prince and Antoinette Sibley as Clara
during a rehearsal for *The Nutcracker*, 1968

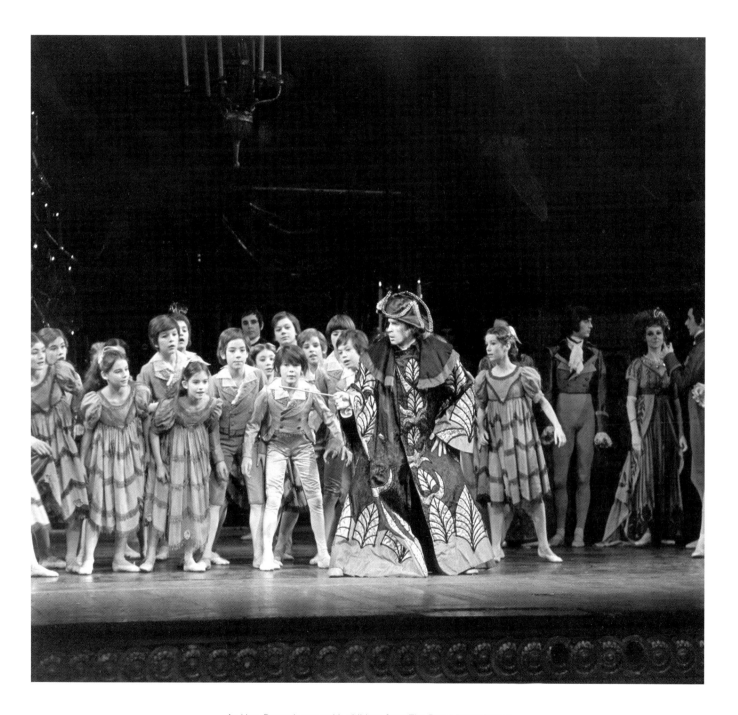

As Herr Drosselmeyer with children from The Royal Ballet School
and Artists of The Royal Ballet in Act I of *The Nutcracker,* 1968

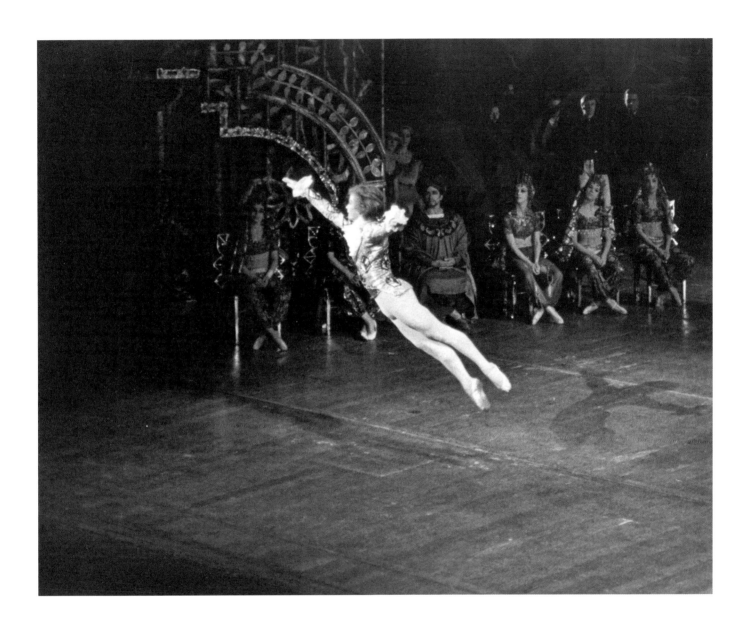

As The Prince in Act II of *The Nutcracker,* 1968

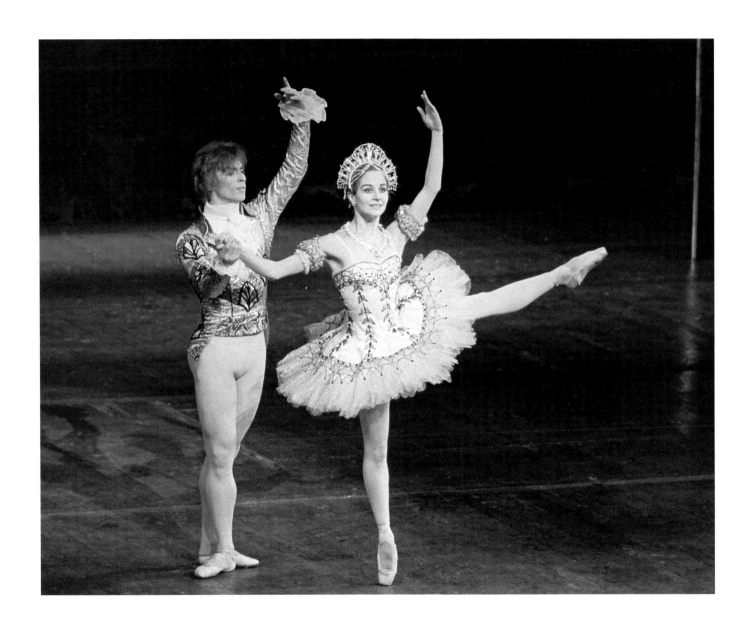

As The Prince with Park as Clara in Act II of *The Nutcracker,* 1968

RAYMONDA

Nureyev first staged his full-length production of *Raymonda,* designed by Beni Montresor, for The Royal Ballet Touring Company at the Spoleto Festival in Italy on 10 July 1964. He appeared as Jean de Brienne with Doreen Wells and then Fonteyn as Raymonda. Subsequently Nureyev staged the one-act *Raymonda Act III,* designed by Barry Kay, for The Royal Ballet Touring Company, which was first performed in Helsinki on 7 May 1966 and taken into the repertory of The Royal Ballet in 1969. The Royal Ballet revived *Raymonda Act III* as part of a programme dedicated to the memory of Rudolf Nureyev in April 2003.

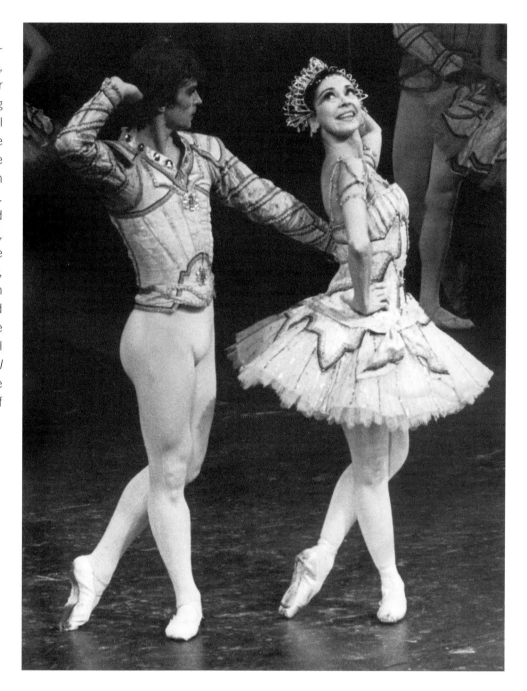

With Fonteyn in *Raymonda Act III,* 1969

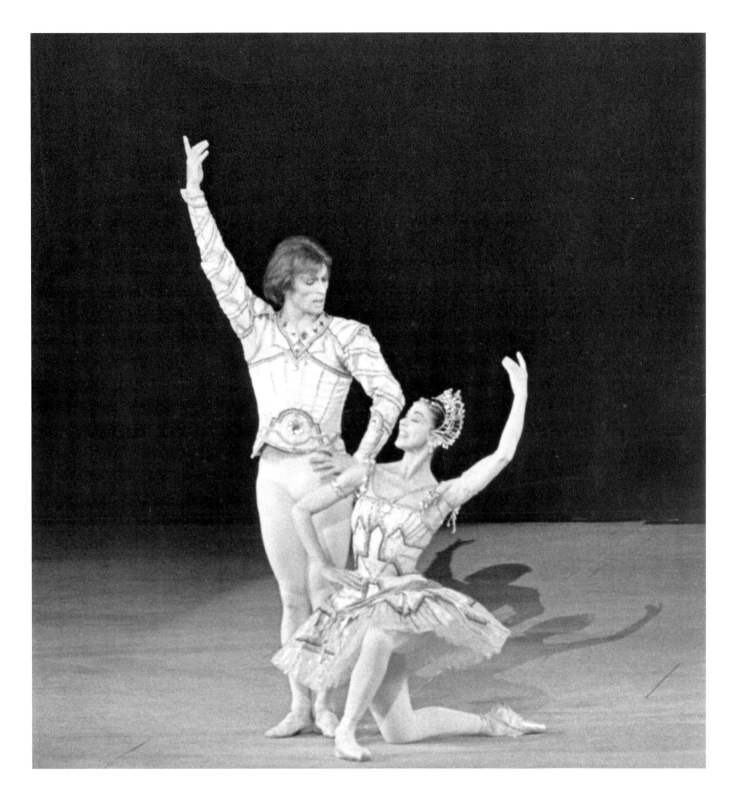

With Fonteyn in *Raymonda Act III,* St Louis, The Royal Ballet American tour, 1969

THE TEMPEST

In 1982, Nureyev returned to The Royal Ballet to create a one-act ballet based on Shakespeare's *The Tempest,* with music by Tchaikovsky, arranged by John Lanchbery, and designs by Nicholas Georgiadis. He created the role of Prospero on Anthony Dowell who danced the first performance and Nureyev also danced the role in the ballet's first season. The cast included Wayne Eagling as Ariel, David Wall as Caliban, Lesley Collier as Miranda and Ashley Page as Ferdinand.

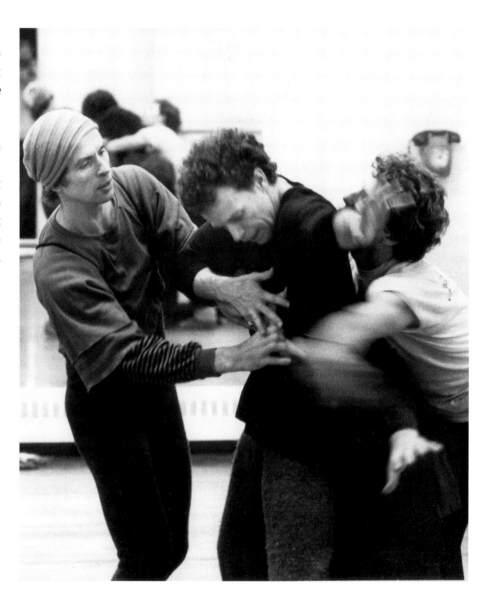

Rehearsing Anthony Dowell *(centre)* as Prospero and Wayne Eagling as Ariel in *The Tempest,* 1982

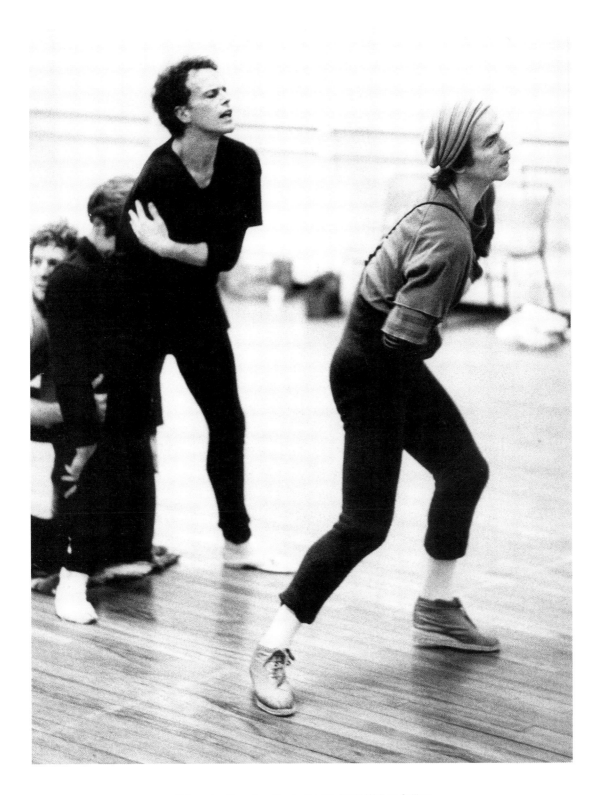

Rehearsing Dowell as Prospero, with David Wall as Caliban
and Eagling as Ariel in *The Tempest*, 1982

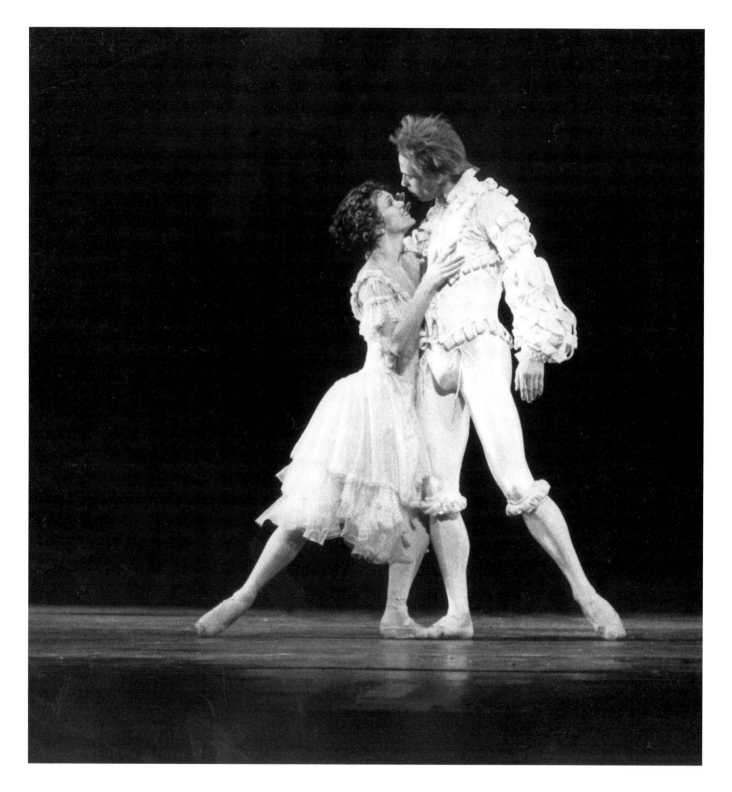

Lesley Collier as Miranda and Ashley Page as Ferdinand in *The Tempest*, 1982

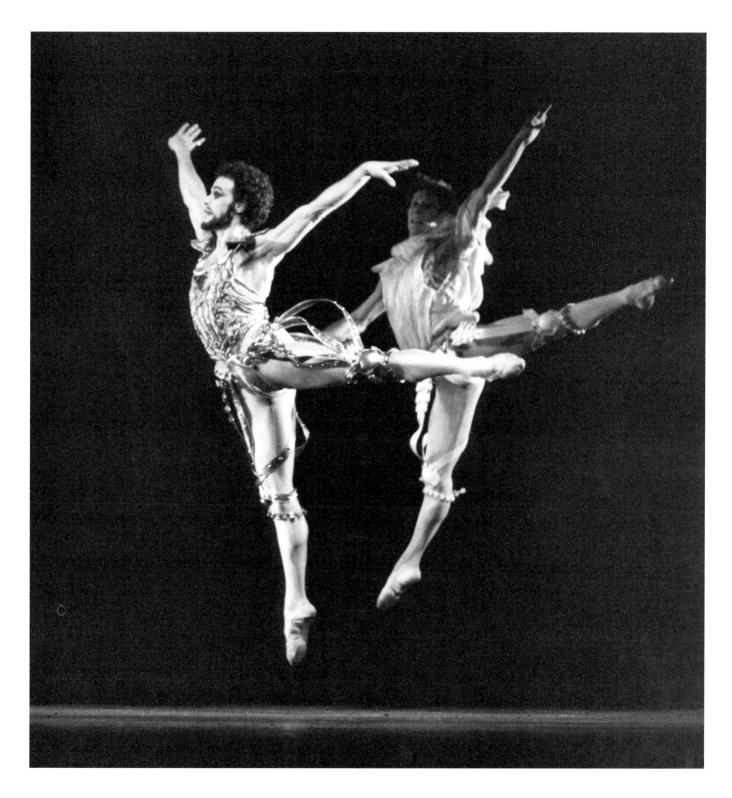

Anthony Dowell as Prospero and Wayne Eagling as Ariel in *The Tempest,* 1982

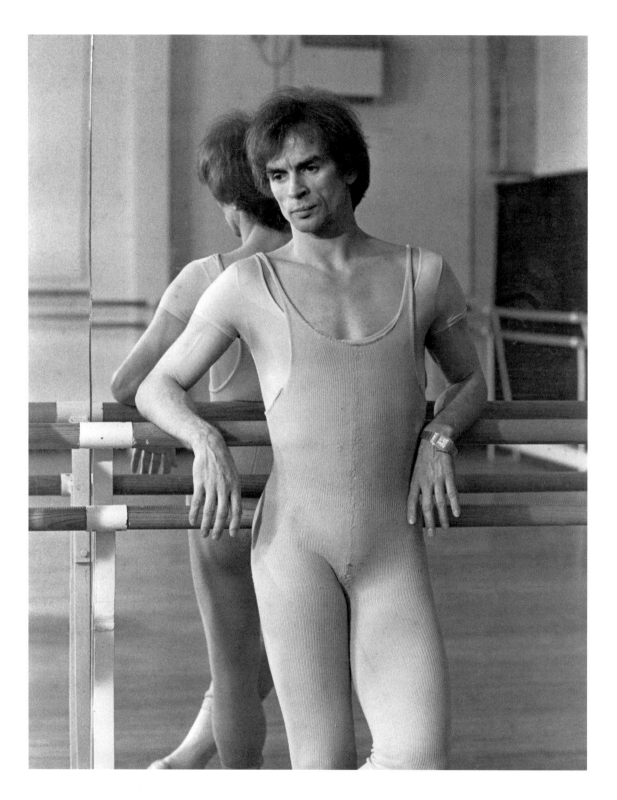

A reflective moment during a rehearsal for *La Bayadère, The Kingdom of the Shades,* 1982

GALAS AND BEHIND THE SCENES

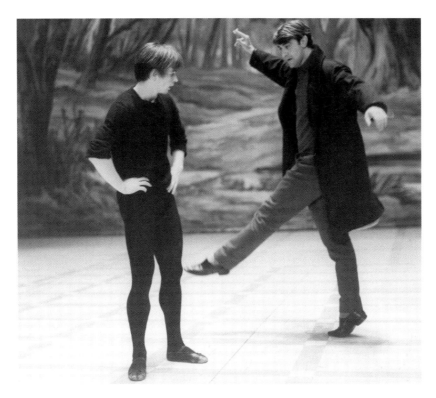

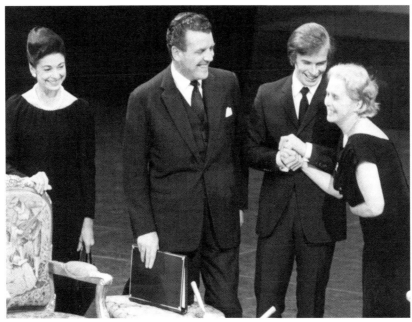

above: With Kenneth MacMillan rehearsing *La Sylphide*
for a Royal Academy of Dancing (RAD) Gala, 1963
below: Explaining the importance of Ninette de Valois to British Ballet with,
left to right, Margot Fonteyn, Eamon Andrews and Ninette de Valois,
This is Your Life, TV, 5 April 1964

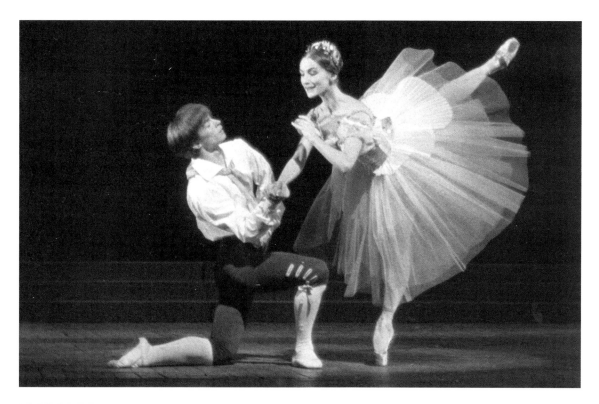

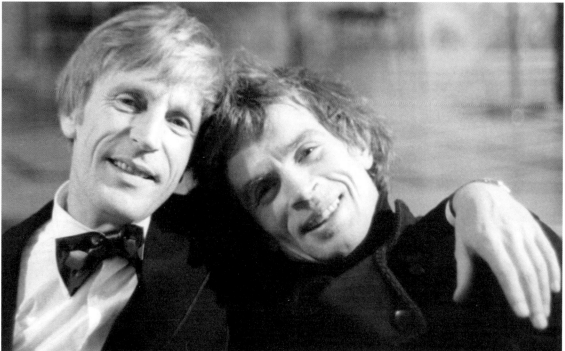

above: With Anya Linden in *Flower Festival at Genzano pas de deux*, 1962
below: With the great love of his life Erik Bruhn

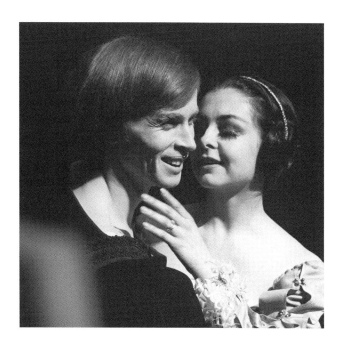

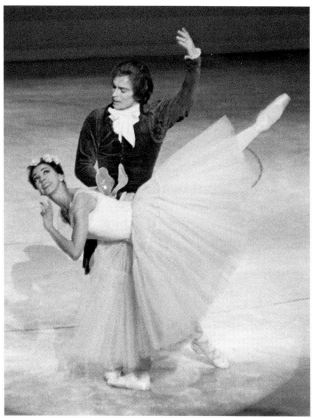

above: Enjoying a joke with his friend Lynn Seymour during a photo call for *Hamlet,* 1964
below: With Fonteyn in *La Sylphide,* live on *Sunday Night at the London Palladium*

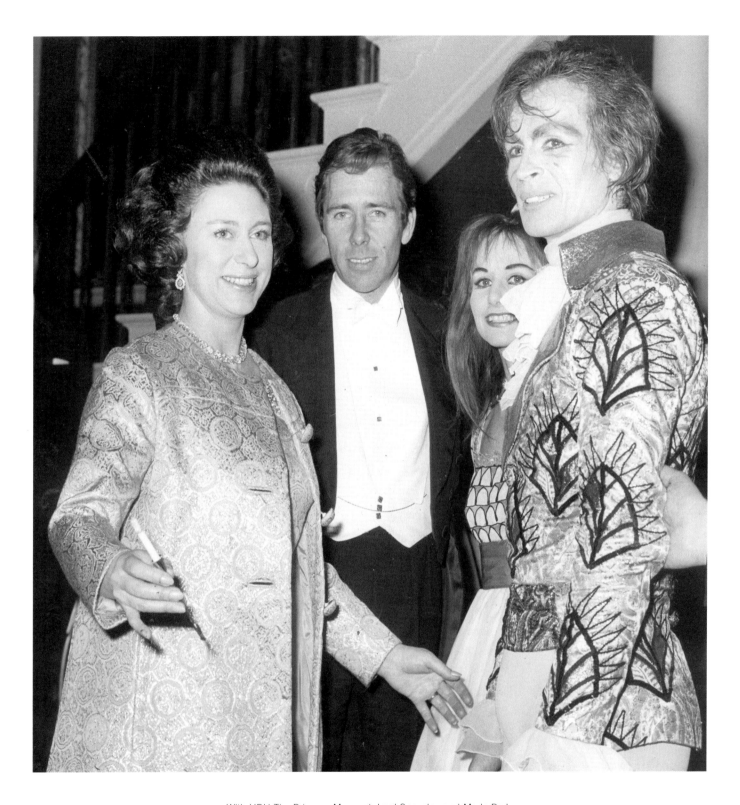

With HRH The Princess Margaret, Lord Snowdon and Merle Park
after the premiere at the Royal Opera House of his production of *The Nutcracker,* 29 February 1968

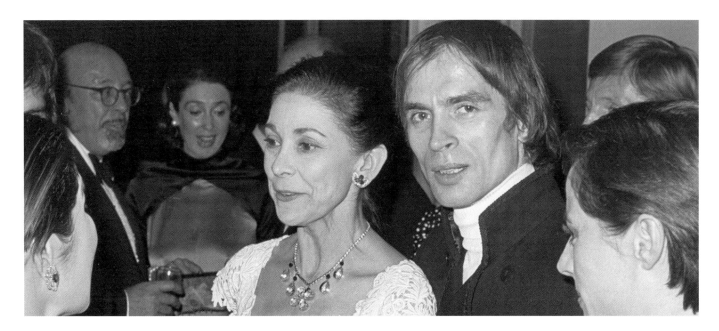

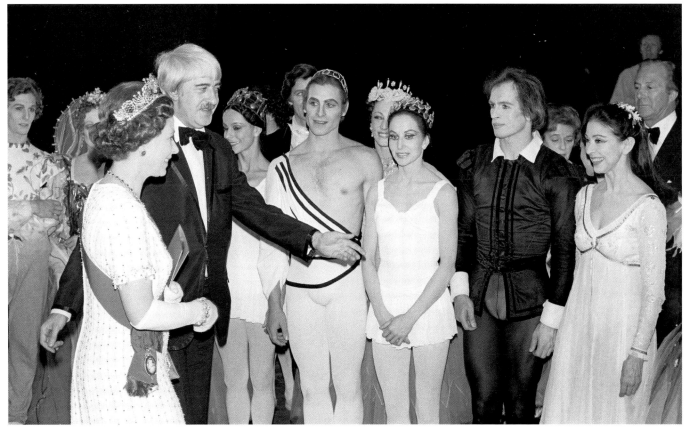

above: With Fonteyn after The Royal Ballet Benevolent Fund Gala, 4 March 1975
below: Kenneth MacMillan introducing Her Majesty Queen Elizabeth II to members of The Royal Ballet
after the Silver Jubilee Gala, 30 May 1977. *Left to right:* David Wall, Merle Park, Nureyev and Fonteyn

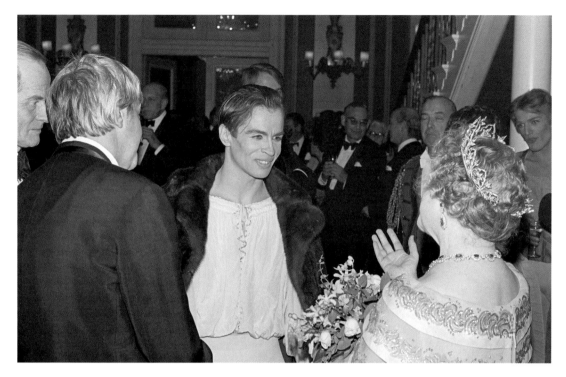

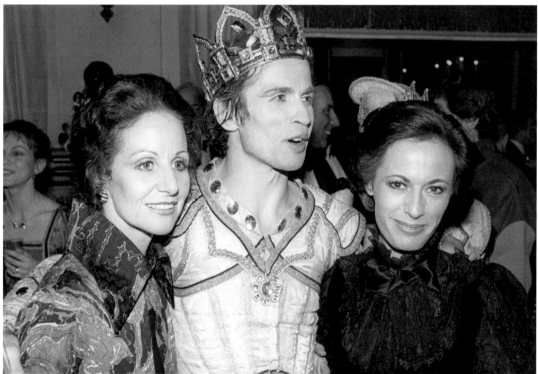

above: With Her Majesty Queen Elizabeth The Queen Mother
after The Royal Ballet Benevolent Fund Gala, 23 November 1976
below: With Merle Park and friend Douce Françoise in costume
for *Raymonda Act III*, 2 December 1982

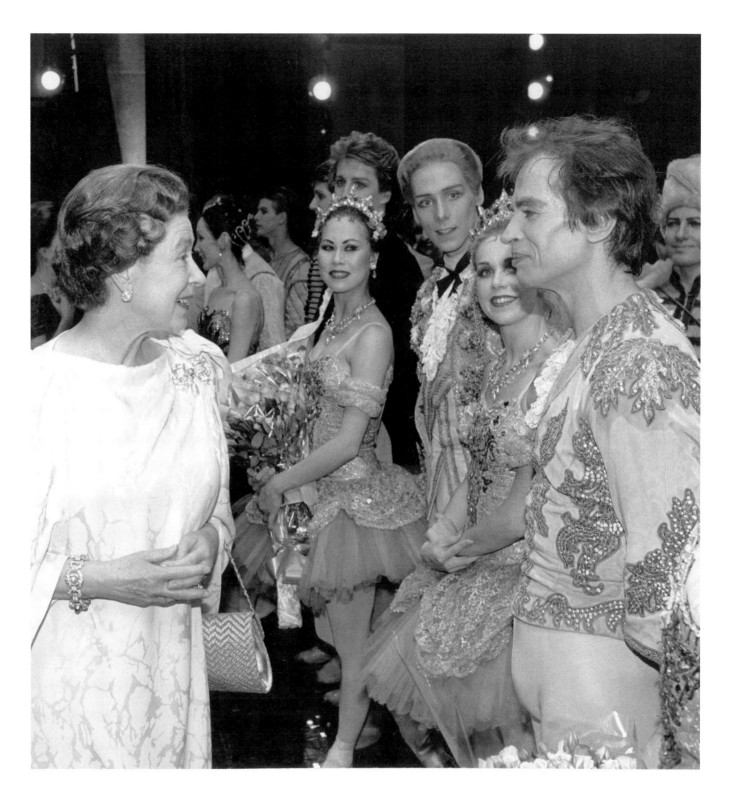

With Her Majesty Queen Elizabeth II after the Gala Night of Ballet
in celebration of Dame Ninette de Valois' 90th Birthday, 6 June 1988

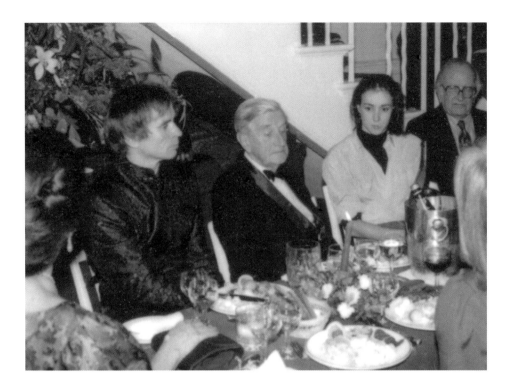

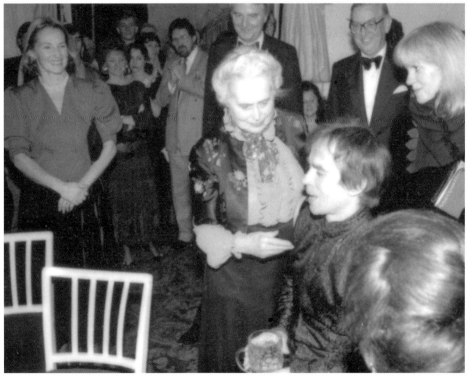

Party in Nureyev's honour after *Giselle,* 1988, in the Crush Room at the Royal Opera House
above: with Frederick Ashton and the young Sylvie Guillem
below: being greeted by Ninette de Valois

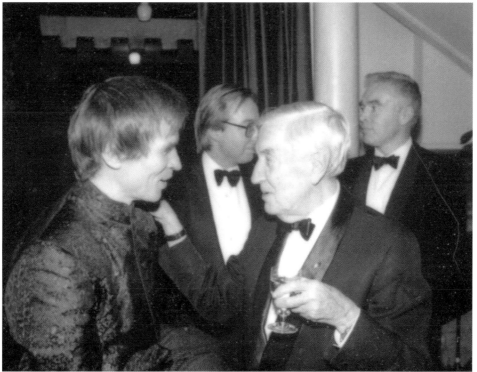

Party in Nureyev's honour after *Giselle*, 1988
above: being toasted by The Royal Ballet
below: with Frederick Ashton

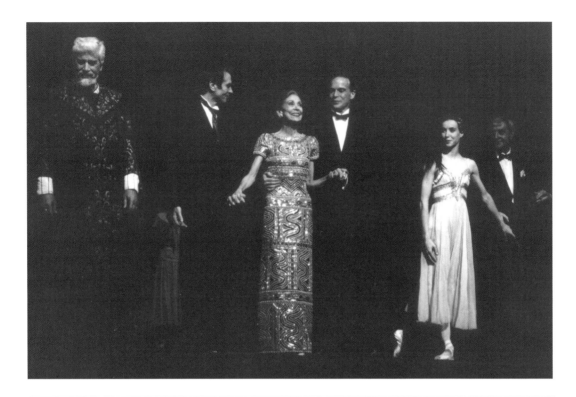

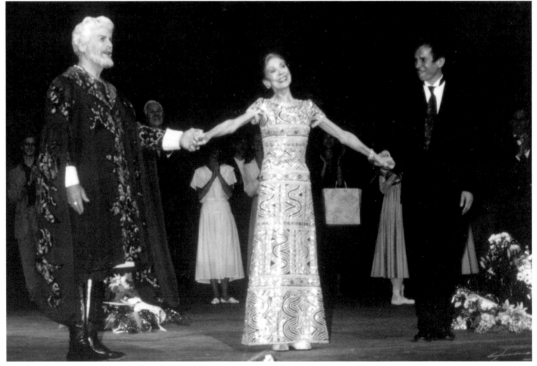

Curtain calls after the performance of *Romeo and Juliet* at the *Tribute to Margot Fonteyn* Gala, 30 May 1990
above: With Michael Somes, Fonteyn, Anthony Dowell, Sylvie Guillem and Kenneth MacMillan
below: With Somes and Fonteyn

Curtain call after dancing Mercutio in the performance of *Romeo and Juliet*
at the *Tribute to Margot Fontcyn* Gala, 30 May 1990, his last appearance with The Royal Ballet at the Royal Opera House

POST SCRIPT

Rudolf Nureyev died in Paris on 6 January 1993. Following a ceremony in the Palais Garnier, home of the Paris Opéra, he was buried in the Russian orthodox cemetery at Sainte Geneviève-des-Bois. Appropriately for the man who never stopped travelling, his tomb is covered with a glorious mosaic travelling rug, designed by theatre designer Ezio Frigerio who worked with Nureyev on several of his productions.

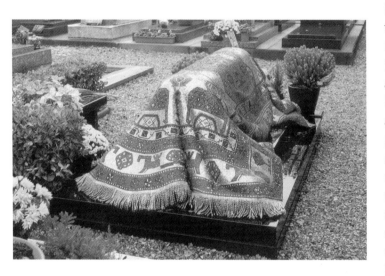

There were many tributes paid across the world. In London, The Royal Ballet remembered Nureyev in an intimate *A Tribute to Rudolf Nureyev,* held at the Royal Opera House on the evening of Sunday 25 April 1993. There were readings and music from works he loved and tributes including a moving personal address by Lynn Seymour.

A Gala Night of Ballet to celebrate the Life of Rudolf Nureyev in the presence of HRH The Princess Margaret took place at the London Coliseum on 13 March 1994. Dancers from around the world gathered together with dancers from The Royal Ballet and English National Ballet to pay tribute and to perform the works he had made his own.

In 2003, on the 10th anniversary of his death, there were again tribute performances around the world. At the Royal Opera House, there was an evening of ballet including *divertissements* set against a tribute film put together by Sylvie Guillem. An exhibition of photographs and costumes recalled some of his many great roles with The Royal Ballet.

The last words belong to Ninette de Valois:
'As time passes, people are inclined to forget the wonderful role Rudolf Nureyev played in the development of the English ballet scene when he joined The Royal Ballet, after his defection from Russia. He lifted us into another dimension in the presentation and execution of the great Russian classics. He had as great an influence on the young dancers of Britain as anyone that I can recall during the last fifty years. His intelligence matched his talent and he used to make many a wise statement about both his own performance and that of the other artists.

The memory of Rudolf Nureyev will remain at Covent Garden for ever. I know how very much I owe to him, both in the development of The Royal Ballet and the wonderful knowledge that he passed on to its dancers.'

Rudolf Nureyev's tomb, Sainte Geneviève-des-Bois, Paris

SELECTIVE CHRONOLOGY

Key: (m): music composed by
 (ch): choreography by
 (s): scenery designed by
 (c): costumes designed by
 (sc): scenery and costumes designed by
 (fp): first performance by The Royal Ballet
 (p): production

1961
For his first performance in London, created
the role of
POÈME TRAGIQUE (m): Alexander Scriabin (ch):
Frederick Ashton (c): William Chappell.
The Royal Academy of Dancing Gala Matinée,
Theatre Royal, Drury Lane,
2 November 1961

1962
Danced as Count Albrecht with Margot Fonteyn
as Giselle in
GISELLE (m): Adolphe Adam (ch): Jean Coralli,
Jules Perrot, revised Nicholas Sergeyev,
Frederick Ashton (p): Frederick Ashton,
Tamara Karsavina (sc): James Bailey.
The Royal Ballet, Royal Opera House,
21 February 1962

Danced with Yvette Chauviré in the *mazurka*
from
LES SYLPHIDES (m): Fryderyk Chopin
(ch): Mikhail Fokine (p): Serge Grigoriev, Lubov
Tchernicheva (sc): after Alexandre Benois. The
Royal Ballet, Royal Opera House, Gala. The
Royal Ballet Benevolent Fund and The Royal
Ballet Endowment Fund, 3 May 1962

Danced with Sonia Arova in
DON QUIXOTE *pas de deux* (m): after Ludwig
Minkus (ch): after Marius Petipa. The Royal
Ballet, Royal Opera House, 14 June 1962

Danced as Etiocles in
ANTIGONE (m): Mikis Theodorakis (ch): John
Cranko (sc): Rufino Tamayo. The Royal Ballet,
Royal Opera House, 1962 revival.

Danced as Prince Siegfried with Sonia Arova as
Odette/Odile in
LE LAC DES CYGNES (m): Pyotr Il'yich
Tchaikovsky (ch): Marius Petipa, Lev Ivanov,
Frederick Ashton (p): Nicholas Sergeyev
(sc): Leslie Hurry. The Royal Ballet, Royal
Opera House, June 1962

Danced as Prince Florimund with Yvette
Chauviré and Nadia Nerina as Princess Aurora in
THE SLEEPING BEAUTY (m): Pyotr Il'yich
Tchaikovsky (ch): after Marius Petipa,
Frederick Ashton, Ninette de Valois
(p): Nicholas Sergeyev, revised 1952
(sc): Oliver Messel. The Royal Ballet, Royal
Opera House, 1962 revival

Danced his first Prince Siegfried with Fonteyn
as Odette/Odile in
LE LAC DES CYGNES (m): Pyotr Il'yich
Tchaikovsky (ch): Marius Petipa, Lev Ivanov,
Frederick Ashton (p): Nicholas Sergeyev
(sc): Leslie Hurry. The Royal Ballet Touring
Company, Nervi, 5 July 1962

Danced with Anya Linden in
FLOWER FESTIVAL AT GENZANO *pas de deux*
(m): E Helsted (ch): August Bournonville.
The Royal Ballet, Royal Opera House,
1 November 1962

Danced with Margot Fonteyn in
LE CORSAIRE *pas de deux* (m): Riccardo Drigo,
Ludwig Minkus, orchestrated John Lanchbery
(ch): after Marius Petipa (c): Fonteyn's tutu
André Levasseur (fp): The Royal Ballet, Royal
Opera House, 3 November 1962

Danced with Margot Fonteyn in
LES SYLPHIDES (m): Fryderyk Chopin
(ch): Mikhail Fokine (p): Serge Grigoriev, Lubov
Tchernicheva (sc): after Alexandre Benois.
The Royal Ballet, Royal Opera House,
6 November 1962

1963
Created the role of Armand with Margot
Fonteyn as Marguerite in
MARGUERITE AND ARMAND (m): Franz Liszt,
orchestrated Humphrey Searle (ch): Frederick
Ashton (sc): Cecil Beaton, scenario: after
Alexandre Dumas *fils* (fp): The Royal Ballet,
Royal Opera House, 12 March 1963

Danced as Petrushka with Nadia Nerina as
The Ballerina in
PETRUSHKA (m): Igor Stravinsky (ch): Mikhail
Fokine (p): revived by Serge Grigoriev, Lubov
Tchernicheva (sc): Alexandre Benois. The
Royal Ballet, Royal Opera House, 1963 revival

Danced in
DIVERSIONS (m): Arthur Bliss (ch): Kenneth
MacMillan (sc): Philip Prowse. The Royal
Ballet, Royal Opera House, 1963 revival

Danced as Solor with Margot Fonteyn as Nikiya
and Lynn Seymour, Merle Park and Monica
Mason as the soloists in
LA BAYADÈRE *Act IV The Kingdom of the
Shades* (m): Ludwig Minkus (ch): Marius
Petipa revised (p): Rudolf Nureyev (c): Philip
Prowse (fp): The Royal Ballet, Royal Opera
House, 27 November 1963

Danced one performance of
SYMPHONIC VARIATIONS (m): César Franck
(ch): Frederick Ashton (sc): Sophie
Fedorovitch. The Royal Ballet, Royal Opera
House, 1 April 1963

1964
Danced as Hamlet with Lynn Seymour as
Ophelia, Monica Mason as Queen of Denmark
and Derek Rencher as King of Denmark in
HAMLET (m): Pyotr Il'yich Tchaikovsky
(ch): Robert Helpmann (sc): Leslie Hurry.
The Royal Ballet, Royal Opera House, 1964
revival

Danced as Prince Siegfried with Margot
Fonteyn as Odette/Odile in
SWAN LAKE (m): Pyotr Il'yich Tchaikovsky
(ch): Marius Petipa, Lev Ivanov, Frederick
Ashton, Rudolf Nureyev, Maria Fay (p): Robert
Helpmann (sc): Carl Toms. The Royal Ballet,
Royal Opera House, 6 March 1964

Created *Two Loves I Have* with Lynn Seymour
and Christopher Gable in
IMAGES OF LOVE (m): Peter Tranchell
(ch): Kenneth MacMillan (sc): Barry Kay.
(fp): The Royal Ballet, Royal Opera House,
2 April 1964

Created the role of Jean de Brienne with
Doreen Wells as Raymonda in his full length
production of
RAYMONDA (m): Alexander Glazunov
(ch): Nureyev after Petipa (sc): Beni Montresor.
(fp): The Royal Ballet Touring Company,
Spoleto Festival, Italy, 10 July 1964

First danced as Hamlet with Margot Fonteyn as
Ophelia in
HAMLET (m): Pyotr Il'yich Tchaikovsky
(ch): Robert Helpmann (sc): Leslie Hurry.
The Royal Ballet Touring Company, Baalbak,
Turkey, 25 July 1964

1965

Created the role of Romeo with Margot Fonteyn as Juliet in
ROMEO AND JULIET (m): Sergey Prokofiev (ch): Kenneth MacMillan (sc): Nicholas Georgiadis (fp): The Royal Ballet, Royal Opera House, 9 February 1965

Danced Polovtsian Warrior with Monica Mason as Polovtsian Girl in
POLOVTSIAN DANCES FROM PRINCE IGOR (m): Aleksandr Borodin (ch): Mikhail Fokine (p): Serge Grigoriev, Lubov Tchernicheva (sc): Nicholas Roerich (fp): The Royal Ballet, Royal Opera House, 24 March 1965

Danced with Nadia Nerina, Merle Park, Antoinette Sibley, Christopher Gable, Graham Usher in
LAURENTIA *pas de six* (m): Alexander Krien, orchestrated by John Lanchbery (ch): Vakhtang Chaboukiani (p): Rudolf Nureyev (sc): Philip Prowse (fp): The Royal Ballet, Royal Opera House, 24 March 1965

Danced the role of Romeo with Margot Fonteyn as Juliet in
ROMEO AND JULIET (m): Sergey Prokofiev (ch): Kenneth MacMillan (sc): Nicholas Georgiadis. The Royal Ballet, Metropolitan Opera House New York, 21 April 1965

1966

Danced first Prince Florimund with Margot Fonteyn as Princess Aurora in
THE SLEEPING BEAUTY (m): Pyotr Il'yich Tchaikovsky (ch): after Marius Petipa, Frederick Ashton, Ninette de Valois (p): Nicholas Sergeyev, revised 1952 (sc): Oliver Messel. The Royal Ballet, Royal Opera House, 26 December 1966

Danced as The Messenger of Death with Anthony Dowell as First Song and Monica Mason as Second Song in
SONG OF THE EARTH (m): Gustav Mahler (ch): Kenneth MacMillan. The Royal Ballet, Royal Opera House, 1966 revival

1967

Created the role of The Man with Margot Fonteyn as The Woman in
PARADISE LOST (m): Marius Constant (ch): Roland Petit (sc): Martial Raysse (fp): The Royal Ballet, Royal Opera House, 23 February 1967

Danced as Solor with Svetlana Beriosova and Merle Park as Nikiya in
LA BAYADÈRE *Act IV The Kingdom of the Shades* (m): Ludwig Minkus (ch): Marius Petipa revised (p): Rudolf Nureyev (c): Philip Prowse. The Royal Ballet, Royal Opera House, 1967/68 revival

1968

Created *Friday* with Antoinette Sibley in
JAZZ CALENDAR (m): Richard Rodney Bennett (ch): Frederick Ashton (sc): Derek Jarman (fp): The Royal Ballet, Royal Opera House, 9 January 1968

Created the role of Herr Drosselmeyer/The Prince with Merle Park as Clara in
THE NUTCRACKER (m): Pyotr Il'yich Tchaikovsky (ch): Rudolf Nureyev, Vassily Vainonen (p): Rudolf Nureyev (sc): Nicholas Georgiadis (fp): The Royal Ballet, Royal Opera House, 29 February 1968

Danced as Prince Florimund with Merle Park as Princess Aurora in
THE SLEEPING BEAUTY (m): Pyotr Il'yich Tchaikovsky (ch): after Marius Petipa, Frederick Ashton (p): Peter Wright (s): Henry Bardon (c): Lila de Nobili, Rostislav Doboujinsky. The Royal Ballet, Royal Opera House, 1968 revival

Danced with Margot Fonteyn in
BIRTHDAY OFFERING (m): Alexander Glazunov, arranged and orchestrated by Robert Irving (ch): Frederick Ashton (s): Sophie Fedorovitch (from Veneziana) (c): André Levasseur. The Royal Ballet, Royal Opera House, 29 March 1968

1969

Created the role of Pélléas with Margot Fonteyn as Mélisande in
PÉLLÉAS ET MÉLISANDE (m): Arnold Schoenberg (ch): Roland Petit (sc): Jacques Dupont (fp): The Royal Ballet, Royal Opera House, 26 March 1969

First performance with Svetlana Beriosova as Raymonda and Donald Macleary as Jean de Brienne in
RAYMONDA ACT III (m): Alexander Glazunov (ch): Rudolf Nureyev (sc): Barry Kay (fp): The Royal Ballet, Royal Opera House, 27 March 1969

1970

Created the role of The Traveller with Monica Mason as Death in
THE ROPES OF TIME (m): Jan Boerman (ch): Rudi van Dantzig (sc): Toer von Schayk (fp): The Royal Ballet, Royal Opera House, 2 March 1970

Danced The Poet with Margot Fonteyn as The Woman in Balldress in
APPARITIONS *Ballroom scene excerpt* (m): Franz Liszt, arranged Constant Lambert (ch): Frederick Ashton (sc): Cecil Beaton The Royal Ballet, *A Tribute to Frederick Ashton* Gala, Royal Opera House, 24 July 1970

Danced in
DANCES AT A GATHERING (m): Fryderyk Chopin (ch): Jerome Robbins (c): Joe Eula (fp): The Royal Ballet, Royal Opera House, 19 October 1970

1971

Danced as Prince Siegfried with Monica Mason as Odette/Odile in
SWAN LAKE (m): Pyotr Il'yich Tchaikovsky (ch): Marius Petipa, Lev Ivanov, Frederick Ashton, Ninette de Valois, Rudolf Nureyev (p): Nicholas Sergeyev revised Ninette de Valois (sc): Leslie Hurry. The Royal Ballet, Royal Opera House, 29 June 1971

Danced as Apollo with Svetlana Beriosova as Terpsichore, Vergie Derman as Polyhymnia and Vyvyan Lorrayne as Calliope in
APOLLO (m): Igor Stravinsky (ch): George Balanchine (sc): John Craxton. The Royal Ballet, Royal Opera House, 1971 revival

Danced as First Red Knight with Monica Mason as The Black Queen in
CHECKMATE (m): Arthur Bliss (ch): Ninette de Valois (sc): E. McKnight Kauffer. The Royal Ballet, Royal Opera House, 1971 revival

1972

Danced in
FIELD FIGURES (m): Karlheinz Stockhausen (ch): Glen Tetley (sc): Nadine Baylis. The Royal Ballet, Royal Opera House, 1972 revival

Danced with Jennifer Penney in
AFTERNOON OF A FAUN (m): Claude Debussy (ch): Jerome Robbins (s): Jean Rosenthal (c): Irene Sharaff. The Royal Ballet, Royal Opera House, 21 February 1972

Created with Lynn Seymour
SIDESHOW (m): Igor Stravinsky (ch): Kenneth MacMillan (c): Thomas O'Neil (fp): The Royal Ballet, Royal Court Theatre, Liverpool, 1 April 1972

Created with Lynn Seymour, Deanne Bergsma and Desmond Kelly
LABORINTUS (m): Luciano Berio (ch): Glen Tetley (sc): Rouben Ter-Arutunian text: Eduardo Sanguineti (fp): The Royal Ballet, Royal Opera House, 26 July 1972

1973
Danced in
AGON (m): Igor Stravinsky (ch): George Balanchine. The Royal Ballet, Royal Opera House, 1973

Danced the role of The Prodigal Son with Deanne Bergsma as The Siren in
THE PRODIGAL SON (m): Sergey Prokofiev (ch): George Balanchine (sc): Georges Rouault (fp): The Royal Ballet, Royal Opera House, 25 January 1973

Danced as Prince Florimund with Natalia Makarova as Princess Aurora in
THE SLEEPING BEAUTY (m): Pyotr Il'yich Tchaikovsky (ch): Marius Petipa, Kenneth MacMillan, Frederick Ashton, Fyodor Lopokov (p): Kenneth MacMillan (sc): Peter Farmer. The Royal Ballet, Royal Opera House, 8 June 1973

Danced as Romeo with Natalia Makarova as Juliet in
ROMEO AND JULIET (m): Sergey Prokofiev, (ch): Kenneth MacMillan (sc): Nicholas Georgiadis. The Royal Ballet, Royal Opera House, 1973 revival

1974
Danced Des Grieux with Merle Park as Manon in
MANON (m): Jules Massenet, orchestrated and arranged by Leighton Lucas and Hilda Gaunt (ch): Kenneth MacMillan (sc): Nicholas Georgiadis. The Royal Ballet, Metropolitan Opera House New York, 1974

Danced Colas with Merle Park as Lise in
LA FILLE MAL GARDÉE (m): Ferdinand Hérold, adapted and arranged by John Lanchbery from 1828 version (ch): Frederick Ashton (sc): Osbert Lancaster. The Royal Ballet, Metropolitan Opera House New York, 1974

1975
Created with Margot Fonteyn
DON JUAN *pas de deux* (m): Christoph Willibald Gluck, Thomas Luis de Victoria (ch): John Neumeier (c): Filippo Sanjust, Anthony Dowell (fp): The Royal Ballet, The Royal Ballet Benevolent Fund Gala, Royal Opera House, 4 March 1975

Danced with Anthony Dowell in
CHANT DU COMPAGNON ERRANT (m): Gustav Mahler (ch): Maurice Béjart (fp): The Royal Ballet, The Royal Ballet Benevolent Fund Gala, Royal Opera House, 4 March 1975

1976
Danced Oberon with Merle Park as Titania in
THE DREAM (m): Felix Bartholdy Mendelssohn, arranged by John Lanchbery (ch): Frederick Ashton (s): Henry Bardon (c): David Walker. The Royal Ballet, Royal Opera House, 1976 revival

1977
Created the role of Hamlet with Margot Fonteyn as Ophelia in
HAMLET PRELUDE (m): Franz Liszt (ch): Frederick Ashton (c): Carl Toms. (fp): The Royal Ballet, Silver Jubilee Gala, Royal Opera House, 30 May 1977

1982
Danced as Prince Siegfried with Lesley Collier as Odette/Odile in
SWAN LAKE (m): Pyotr Il'yich Tchaikovsky (ch): Marius Petipa, Lev Ivanov, Rudolf Nureyev (Act I Prince's Variation) (p): Norman Morrice (sc): Leslie Hurry. The Royal Ballet, Royal Opera House, 13 February 1982

Danced as Solor with Bryony Brind as Nikiya in
LA BAYADÈRE *Act IV The Kingdom of the Shades* (m): Ludwig Minkus (ch): Marius Petipa revised (p): Rudolf Nureyev (c): Philip Prowse. The Royal Ballet, Royal Opera House, 27 February 1982

Danced as Count Albrecht with Lesley Collier as Giselle in
GISELLE (m): Adolphe Adam (ch): Jean Coralli and Jules Perrot (p): Norman Morrice (sc): James Bailey. The Royal Ballet, Royal Opera House, 3 November 1982

Created for The Royal Ballet
THE TEMPEST (m): Pyotr Il'yich Tchaikovsky (ch): Rudolf Nureyev (sc): Nicholas Georgiadis (fpnp): The Royal Ballet, Royal Opera House, 2 December 1982. Nureyev created the role of Prospero on Anthony Dowell and danced the role himself for the first time at the second performance on 3 December 1982

Danced in
KONSERVATORIET (m): Holger Simon Paulli (ch): August Bournonville (p): Mona Vangsaae (sc): David Walker (fp): The Royal Ballet, Royal Opera House, 2 December 1982

1988
Danced Count Albrecht with Sylvie Guillem as Giselle in
GISELLE (m): Adolphe Adam (ch): Marius Petipa after Jean Coralli and Jules Perrot (p): Peter Wright (sc): John Macfarlane. The Royal Ballet, Royal Opera House, 6 January 1988 Sylvie Guillem's first appearance with The Royal Ballet

1990
Nureyev's last performance with The Royal Ballet was as Mercutio in
ROMEO AND JULIET (m): Sergey Prokofiev (ch): Kenneth MacMillan (sc): Nicholas Georgiadis. The Royal Ballet *A Tribute to Margot Fonteyn* Gala, Royal Opera House, 30 May 1990